1•2•3 ART

Open-Ended Art
For Young Children

Totline® Publications
A Division of Frank Schaffer Publications, Inc.
Torrance, California

Thanks to all the TOTLINE® subscribers who have enthusiastically contributed open-ended art activities for this book, and a very special thank you to Marion Hopping Ekberg for her delightful drawings.

Jean Warren

Editor: Elizabeth S. McKinnon
Cover Design: Larry Countryman

ISBN 0-911019-06-5

Library of Congress Catalog Card Number 85-050434
Printed in the United States of America
Published by: Totline Publications

Editorial Office: P.O. Box 2250
Everett, WA 98203

Business Office: 23740 Hawthorne Blvd.
Torrance, CA 90505

INTRODUCTION

1•2•3 ART is an attempt to provide parents and teachers an abundance of open-ended art activities for working with young children.

Preschool children need materials and activities through which they can express their ideas and feelings. They need creative, rather than predetermined, activities. They need materials which, by their nature, are nonrestrictive. **1•2•3 ART** is designed to emphasize process, not product.

Children become creative not by what they produce, but by what they attempt and explore. Children develop self-confidence and decision-making techniques when they are allowed to determine the outcome of their projects.

Safe, nonrestrictive materials are great for all ages of children. The really nice thing about them, however, is that they are appropriate for toddlers and special education youngsters. Creative beginners need the freedom to explore without experiencing failure.

I am very pleased to have had the opportunity to compile the "over 200" open-ended art ideas submitted to the TOTLINE newsletter by parents and teachers across the country into this very usable collection.

Jean Warren

HANDY SEASONAL INDEX

Because of the nature of **1•2•3 ART**, the ideas in this book have not been grouped according to specific seasonal activities. All activities are appropriate for any time of the year. However, to aid you in locating activities which are especially adaptable for certain seasons or holidays, we have provided a handy Seasonal Index at the end of the book.

CONTENTS

PAINTING WITH . . .

PAINTING ON . . .

* * * * *

GLUING . . .

GLUING . . .

GLUING WITH . . .

* * * * *

PRINTING WITH . . .

PRINTS OF . . .

* * * * *

MODELING WITH . . .

MARKING WITH . . .

* * * * *

TEARING OR CUTTING . . .

* * * * *

LACING . . .

* * * * *

MISCELLANEOUS ART . . .

* * * * *

SEASONAL INDEX

PAINTING

Painting with . . .

SHAVING CREAM

"holiday shapes"

"happy faces"

"snow pictures"

MATERIALS:

Fingerpaint paper or white glossy wrapping paper, large aerosol can of shaving cream, powdered tempera or food coloring.

PREPARATION:

Cut the fingerpaint paper or wrapping paper into desired sizes and shapes such as squares, circles, triangles, hearts, eggs or shamrocks. Wet the paper with a sponge and, on each paper, squeeze a puff of shaving cream. Add a dash of tempera paint or food coloring for color desired.

ACTIVITY:

Have the children fingerpaint, first working in the color and then making designs on their papers. This gives the children visual experience with changing color as well as fine motor experience.

SENT IN BY: Betty Ruth Baker, Waco, TX

VARIATION: From Nancy J. Heimark, Grand Forks, ND

Let the children fingerpaint with the shaving cream directly on a waterproof surface. Making different shapes is popular, as are making "happy faces" or letters in the children's names. Cleanup is easily accomplished with a wet sponge, and the shaving cream washes off little hands in seconds.

VARIATION: From Marlene V. Filsinger, Snyder, NY

Spray shaving cream on a table surface or on plastic placemats and invite the children to fingerpaint. When each child has finished experimenting, press a paper on top of his or her design. The print will look like a snowy day!

HINT: From B. Silkunas, Philadelphia, PA

Be sure to dampen the table top before you apply the shaving cream, as it facilitates the movement of fingerpainting.

VARIATION: From Judy Coiner, West Plains, MO

Have the children fingerpaint with shaving cream on clean cookie sheets. Put powdered tempera in old salt shakers and sprinkle paint on the shaving cream. Different colors add interest.

SIMILAR IDEA SUBMITTED BY:
Suzanne L. Friedrich, Pittsburgh, PA

Painting with . . .

MATERIALS:

White paper towels, black non-permanent marking pen, water, small brushes.

PREPARATION:

Draw a large black heart outline on a paper towel for each child.

ACTIVITY:

Let your children brush water over their black heart outlines. Soon the dye in the lines will start to bleed, showing the many colors actually in the black ink. Some colors will spread faster than others, leaving definite color rings around the heart outlines.

WATER

"house painting"

MATERIALS:

Coffee cans, 2-inch brushes, water.

ACTIVITY:

Give each child a coffee can "bucket" and a brush and fill the can with enough water to cover the brush. These simple materials will keep even very young children quite involved in various "painting" projects. Inside, they can paint a chalkboard. Outside, the choices are endless: sides of buildings, fences, cars, bikes, sidewalks, etc.

SENT IN BY: Cynthia Holt, Danbury, CT

HINT: From Nancy Heimark, Grand Forks, ND

Take advantage of this activity to help your children understand what happens when water is exposed to air. They can discover by blowing on an area that moving air makes the water evaporate more quickly.

SIMILAR IDEA SUBMITTED BY: B. Silkunas, Philadelphia, PA

Painting with . . .

FOOD COLORING

"paper towels"

MATERIALS:
Plain paper towels, food coloring, water, small containers, brushes, tape.

PREPARATION:
Pour water into small containers and add food coloring. Tape a paper towel to the table for each child.

ACTIVITY:
Have the children dip their brushes into the colored water and paint designs on their paper towels.

HINTS:
This activity works best with small amounts of water in the containers. Once a paper towel is completely soaked, supply the child with a new one and let the old one dry. For display, mount the paper towels on colored construction paper.

SENT IN BY: Gina Masci, Arlington, MA

"batik look"

VARIATION: From Jane Yeiser Woods, Sarasota, FL
Fold the paper towels and let your children paint them with the colored water. When the towels are unfolded, they will have a batik look. Mix strong colors and encourage the children to dot the colored water on the towels rather than brush it on.

VARIATION: From Jan Goldstein, Indianapolis, IN
Have the children use small plastic cocktail straws to drip the colored water onto the towels, creating circle designs. Frame the pictures and hang them in a window.

VARIATION: From Cindy Dingwall, Palatine, IL
Hand out white paper and straws. Drop small amounts of water mixed with watercolors or food coloring onto the children's papers. Then let them blow the colored water with their straws to create designs.

"straw painting"

SIMILAR IDEA SUBMITTED BY: Dorene Grady, Gig Harbor, WA

Painting with . . .

MATERIALS:

One or more coffee filters for each child, food coloring, aluminum pans, eyedroppers, newspaper, water.

PREPARATION:

Mix small amounts of food coloring and water in pans. Cover the table with a thick layer of newspaper.

"coffee filters"

ACTIVITY:

Demonstrate how to use an eyedropper by "squeezing in" and "letting go." Let the children experiment with their eyedroppers by dripping colored water on the newspaper. Then let them explore what happens when they drip the different colors onto their coffee filters. Place filters on newspaper to dry.

HINT:

Hang the dried filters as mobiles.

SENT IN BY: Diane Torgan, Englewood, CO

FOOD
COLORING

"dippity do"

MATERIALS:

Fluted coffee filters, food coloring, water, jar lids, newspaper.

PREPARATION:

Mix red, yellow and blue food coloring with water and pour small amounts of each color into jar lids.

ACTIVITY:

Have the children dip folded filters in and out of the diluted food coloring so that the colors overlap. Unfold filters and dry them on newspaper.

HINTS:

Use only a small amount of colored water in each lid and watch to see that children don't leave their filters in until all the liquid is absorbed. Paper towels may also be used, but they tear more easily when wet.

SENT IN BY: Barbara H. Jackson, Denton, TX

FOOD COLORING

"butterflies"

VARIATION: From Ruth Engle, Kirkland, WA

Let the children dip the corners and sides of folded paper napkins or white tissue paper into mixtures of food coloring and water. If working with tissue paper, allow it to dry before unfolding, as it tends to rip easily when wet. To dry, hang folded papers by clothespins on a string stretched across a window opening.

VARIATION:

The batik-like paper can also be used to make butterfly wings. Have the children pinch their papers together in the middle and slip them into the slots of old-style clothespins.

ICE

"cool art"

"icicles"

MATERIALS:
Freezer wrap or fingerpaint paper, ice cube tray, popsicle sticks, powdered tempera, shaker containers, newspaper.

PREPARATION:
The night before, freeze a tray of ice cubes with a popsicle stick in each cube. (Sticks do not have to be entirely vertical.) Fill shake containers with powdered tempera paint. Cover work table with newspaper.

ACTIVITY:
Have your children rub their ice sticks across the shiny freezer wrap or fingerpaint paper. Then let them sprinkle on some dry paint. Children love to watch the ice melt into the color.

HINT:
One ice stick can be shared by several children, if desired.

SENT IN BY: Carolyn Tyson, Ann Arbor, MI

VARIATION:
Try doing this activity with icicles if they are available to you in the winter. Children may need to wear gloves.

Painting with . . .

FLOUR

MATERIALS:

Construction paper, squeeze bottles, flour, water, food coloring.

PREPARATION:

Cut construction paper into shapes such as Christmas trees, Valentine hearts or Easter eggs. Fill squeeze bottles with a runny mixture of flour and water and add a few drops of food coloring to each bottle.

"Christmas trees"

ACTIVITY:

Let your children squeeze the colored flour and water mixture onto their paper shapes to make interesting designs.

"hearts"

VARIATION:

Mix equal parts of salt and flour together before adding water to make runny mixture. Then let the children squeeze designs on styrofoam trays or sheets of cardboard.

"Easter eggs"

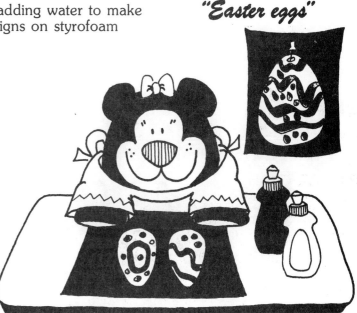

CORN STARCH

"dripless paint"

MATERIALS:

Easel paper, cornstarch, water, liquid tempera, large brushes, paint cups.

PREPARATION:

Add cold water to ¾ cup cornstarch to make a smooth, thick paste. Stir in boiling water until mixture is desired consistency. It should be quite thick and nearly clear. Spoon mixture into paint cups and stir 3 or 4 teaspoons of liquid tempera into each cup.

ACTIVITY:

Let the children brush this nearly dripless paint on large sheets of easel paper to make designs or pictures.

VARIATION:

This mixture can also be used for fingerpainting. Store in refrigerator.

SENT IN BY: Lanette L. Gutierrez, Olympia, WA

Painting with . . .

SHOE POLISH

MATERIALS:

Plastic bottles of white, black and brown liquid shoe polish with sponge applicators, colored construction paper.

ACTIVITY:

Have the children draw on their papers with the shoe polish applicators as if they were using giant magic markers. Dots can be made by picking up the applicators and then pressing them down on the paper.

HINTS:

Have the children use just one color at first. Later, add other colors. The children will enjoy mixing colors on their papers to make new ones, such as white and black to make gray.

To create pastel colors, pry the sponge applicator tops off bottles of white shoe polish and add drops of food coloring.

This type of painting creates little mess, since the children don't have to touch the sponge part of the applicators.

VARIATION:

When a shoe polish bottle is empty, pry off the applicator, wash out the bottle and fill it with watery tempera paint.

VARIATION:

Have the children use white shoe polish to draw snowballs, snowmen, big snowflakes and snow scenes on blue construction paper.

"snowflakes"

VARIATION:

Cut candy cane shapes out of red construction paper and let the children draw white shoe polish stripes on them. The candy canes may be hung as decorations on a Christmas tree.

"candy canes"

14

Painting with . . .

SHOE POLISH

"spring trees"

VARIATION:

Draw brown shoe polish trees on construction paper and let the children dab white shoe polish blossoms on the branches. Add yellow or red food coloring to the white polish for pastel blossoms.

VARIATION:

Let the children use brown shoe polish to draw mud puddles on construction paper. Cut out animal shapes (pigs in particular) to use for "playing in the mud."

"mud puddles"

VARIATION:

Cut oval shapes out of construction paper and let the children make Easter eggs by decorating their shapes with pastel shoe polish lines and dots.

"Easter eggs"

VARIATION:

Have the children draw cloud shapes with white shoe polish on blue construction paper. Let them discuss what the cloud shapes look like as a follow-up language activity.

"summer clouds"

VARIATION:

Let the children use white shoe polish on blue construction paper to draw whitecapped waves on a lake, ocean or river. A sandy beach can be made with brown shoe polish.

"waves"

VARIATION:

Draw brown shoe polish trees on construction paper and let the children dab on brown polish bark. Then let them dab on brown or yellow shoe polish leaves, some on the branches and others falling to the ground.

"autumn leaves"

VARIATION:

Have the children draw white shoe polish ghosts on black construction paper or spooky black shapes and shadows on orange construction paper.

"ghosts"

SENT IN BY: Susan A. Miller, Kutztown, PA

Painting with . . .

CHOCOLATE PUDDING

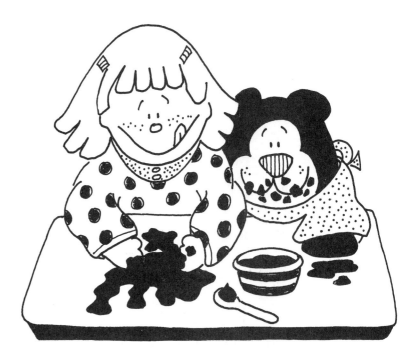

MATERIALS:

Fingerpaint paper, ready-made chocolate pudding, spoons, paint shirts, water, newspaper.

PREPARATION:

Arrange all the materials on the work table, covering the table with newspaper first, if desired.

ACTIVITY:

Let each child spread out a large spoonful of pudding mixed with some water on his or her paper. Then encourage the children to experiment with finger and hand painting. When they have finished, hang their paintings to dry.

"finger fun"

HINT:

This is a great activity to use when studying the five senses, especially those of taste, smell and touch.

SENT IN BY: Jane M. Spannbauer, So. St. Paul, MN

VARIATION: From B. Silkunas, Philadelphia, PA

Have the children fingerpaint directly on a very clean formica-topped table. Once designs are created, paper can be pressed on top of them to make prints.

"prints"

Painting with . . .

CORN SYRUP

MATERIALS:

Posterboard, food coloring, light corn syrup, paint shirts.

ACTIVITY:

Let each child pour a small amount of corn syrup on posterboard and spread it out to the edges. Help the child squeeze a few drops of food coloring in various colors on different areas. Then encourage the child to blend in the colors slightly with his or her fingers. The process is fun, cleanup is "tasty" and the finished product is a shiny, multicolored picture.

VARIATION:

Let the children paint with plain corn syrup on colored posterboard cut into seasonal or holiday shapes such as red hearts, blue kites or green shamrocks or trees. Smaller shapes can be used as Christmas decorations. For additional sensory effects, add scented extracts or sprinkle on some glitter.

SENT IN BY: Myrna Andres, Manassas, VA

"shiny shapes"

CORN SYRUP

"brilliant blends"

MATERIALS:

Large paper plates, light corn syrup, red, blue and yellow food coloring, squeeze bottles, such as those used for catsup or mustard.

PREPARATION:

Pour corn syrup into clean bottles until they are half full. Add a few drops of different colored food coloring to each bottle and shake gently. Add more color, if necessary, to make strong, bright shades.

ACTIVITY:

Have the children squeeze the colored syrup onto their paper plates. Encourage them to squeeze gently so that the syrup falls in drops rather than in a stream. Once this is done with all three colors, have the children tip their plates back and forth so that the colors blend and create new colors. Let the plates dry for several days.

SENT IN BY: Vicki Claybrook, Kennewick, WA

17

Painting with . . .

FINGERS

MATERIALS:

Paint shirts, liquid starch, powdered tempera or food coloring, painting surface such as fingerpaint paper, butcher paper, paper sacks, cardboard, formica table top, cookie sheets or oilcloth.

PREPARATION:

Put about a tablespoon of liquid starch in the middle of each child's paper. Add about a teaspoon of powdered paint or a few drops of food coloring to the starch. (Keep in mind that food coloring will stain hands.)

ACTIVITY:

Have the children use both their hands to mix the color into the starch. Then let them continue using their hands and fingers to create designs and pictures in the paint. Encourage the children to use their hands in many different ways. They can get various effects by pointing fingers down, laying fingers flat, pounding with the side of a clenched fist, pressing hands down with fingers spread out wide and by using fingertips and knuckles.

VARIATION:

Sprinkle some salt or sawdust onto the fingerpaint and let the children mix it into the paint with their hands. This will give added texture to their pictures.

VARIATION:

Let the children create additional designs on their fingerpaintings by using tools such as small pieces of cardboard, old combs, popsicle sticks, cotton swabs or forks.

VARIATION:

Instead of using liquid starch, let your children fingerpaint with a paste made out of soap and water or hand lotion with a drop of food coloring added.

Painting with . . .

VARIATION: From Cathryn Abraham, St. Charles, IL

Cut the centers out of pieces of construction paper to make frames for completed fingerpaintings. Staple frames on top of the paintings.

VARIATION: From Lanette L. Gutierrez, Olympia, WA

To make seasonal pictures, cut the children's papers into seasonal shapes before or after they make their fingerpaintings. Some examples would be heart shapes for Valentine's Day, shamrock shapes for St. Patrick's Day and egg shapes for Easter.

"seasonal shapes"

HINTS: From Lanette L. Gutierrez, Olympia, WA

Place a "fence" of masking tape on the paint table to help contain fingerpaint to a desired area. Use a shower curtain or outdoor grass carpet under the table to catch spills.

VARIATION: From Cynthia Holt, Danbury, CT

Let the children stand while fingerpainting. This allows for greater freedom of movement and helps with rhythm and coordination. Homemade fingerpaint tends to chip off paper, so let the children paint right on the table top. They will love washing the table afterwards. Smock washing is also a great follow-up activity.

HINT: From Cynthia Holt, Danbury, CT

If you don't have a sink near your work area, keep a bucket of soapy water and towels close by.

VARIATION: From Nancy J. Heimark, Grand Forks, ND

Have the children fingerpaint directly on a waterproof surface such as a formica table top. After they have created pictures or designs, let them press paper on top of their paintings to make prints.

"prints"

VARIATION: From Suzanne L. Friedrich, Pittsburg, PA

Let the children fingerpaint on plastic cafeteria trays or large styrofoam meat trays. For each child, spoon one or two colors of fingerpaint onto a tray and have him or her fingerpaint a design. When the child has finished, press a piece of paper cut to fit the tray onto the design and lift. Additional paint can be added to the tray for the next child.

Painting with . . .

PINE BRANCHES

"pine patterns"

MATERIALS:
Pine branches, pinecones, easel paper, paint.

PREPARATION:
Pour paint into shallow containers.

ACTIVITY:
Have the children use the pine branches and pinecones to paint at the easel. They'll enjoy seeing the different types of patterns these materials make.

VARIATION:
This activity can also be done with other kinds of small tree branches, ferns, feathers and grasses such as hay or wheat.

SENT IN BY: Mary Haynes, Lansing, MI

VARIATION: From Jane Roake, Oswego, IL
Let the children use 3-inch to 4-inch branches of various evergreens to dab paint on paper. After they have finished, staple each child's branch on his or her painting. When doing this activity, discuss the smell, texture and color of different evergreens.

QUEEN ANNE'S LACE

"fireworks"

MATERIALS:
Several stalks of Queen Anne's Lace, red, yellow and white paint, dark paper.

PREPARATION:
Pour paint into shallow containers.

ACTIVITY:
Have the children dip the Queen Anne's Lace blossoms into paint and lightly dab them on their papers. The finished products resemble brilliant fireworks displays.

SENT IN BY: Ann Fair, Uniontown, MD

Painting with . . .

FEATHERS

MATERIALS:

Single feathers or feathers clipped in clothespins or feather dusters, tan or brown construction paper, paint, newspaper.

PREPARATION:

Cut a turkey shape out of construction paper for each child.

ACTIVITY:

Have the children place their turkey shapes on pieces of newspaper. Then let them dip their feathers in paint and brush it on their turkeys' bodies.

"turkeys"

VARIATION:

If you're using single feathers, let each child stick several of them on his or her painted turkey shape. The result will be a painting and a collage of feathers, as well.

SENT IN BY: Nancy J. Heimark, Grand Forks, ND

YARN

"worms"

"butterflies"

"flowers"

"snakes"

MATERIALS:
8½" x 11" manila paper, brown liquid tempera, small jars, 6 inches of string for each child.

PREPARATION:
Mix tempera to a consistency that won't drip, but is not too thick, either. Pour into jars. Talk to the children about how worms crawl, wiggle and squirm, or observe a real worm, if possible.

ACTIVITY:
Have each child dip a string into a jar of tempera, keeping one end paint-free. Then have the child drag the string across his or her paper as a worm would crawl or wiggle. Encourage the children to continue dipping their strings and painting until their papers are covered with "worm tracks."

HINT:
Mix tempera with an inexpensive dishwashing soap for easy removal from clothing.

SENT IN BY: Lois Olson, Webster City, IA

VARIATION: From Agnes Kirchgasler, Salt Lake City, UT
Soak 7-inch lengths of string in paint. For each child, place a string inside a folded piece of light-colored paper in a twisted fashion with one end out over the edge. Then have the child place one hand on top of the paper while pulling the string out with the other hand. Open the paper and enjoy the butterfly, dancers or flowers created. Repeat the procedure with other colors to mix.

VARIATION: From Agnes Kirchgasler, Salt Lake City, UT
Play some music during art time. Have the children dip string in paint and let it "dance" across their papers as you vary the tempo.

VARIATION:
From Carolyn Tyson, Ann Arbor, MI

Attach 5-inch yarn pieces to popsicle sticks. Using the sticks as handles, let the children dip the yarn into paint and then wiggle it across their papers t/ make wiggle worms or snakes. Using more than one color of paint makes the project more attra tive and fun.

Painting with . . .

MATERIALS:

Liquid tempera paint, salt, spoons, brown paper bags or fingerpaint paper, paint containers.

PREPARATION:

Pour paint into containers and mix with salt.

ACTIVITY:

Put a spoonful of paint on each child's paper. Then let the child push the paint around with the spoon. Add more paint as needed. The paint and salt mixture provides a texture and sound that children like.

SENT IN BY: Janet Helgaas, Luverne, MN

CRUMPLED PAPER

MATERIALS:

Construction paper or other heavy paper, newspaper, various colors of tempera paint, paint pans.

PREPARATION:

Pour tempera paint into shallow pans. Crumple newspaper.

ACTIVITY:

Have the children dip crumpled newspaper into paint and dab it onto construction paper. Let the paper dry and cut it into egg shapes.

"eggs"

VARIATION:

You may want to cut out the egg shapes before the children paint them. This is also a good activity for making kite shapes or other spring items.

"kites"

SENT IN BY: Sally J. Horton, Waukegan, IL

Painting with . . .

ROLL-ON DEODORANT BOTTLES

MATERIALS:

Empty glass roll-on deodorant bottles, one for each color desired, tempera paint, newsprint, construction paper or manila paper.

PREPARATION:

Remove rollers from bottles and clean both rollers and bottles thoroughly. Fill bottles with tempera paint and replace rollers.

ACTIVITY:

Let the children use the roller bottles to draw pictures or designs on their papers.

SENT IN BY: Ruth Engle, Kirkland, WA

VARIATION: From Betty Ruth Baker, Waco, TX

Encourage the use of several different color combinations in the children's drawings or designs.

"magic markers" **VARIATION:** From Rosemary Spatafora, Pleasant Ridge, MI

Have the children use the deodorant bottles like magic markers. It's interesting to use both large and small roller heads to create designs.

SIMILAR IDEAS SUBMITTED BY: Cathryn Abraham, St. Charles, IL
Lena Goehring, Columbus, PA
Joyce Marshall, Whitby, Ontario
B. Silkunas, Philadelphia, PA

Painting with . . .

SPRAY BOTTLES

MATERIALS:
Empty spray bottles, thinned tempera paint, large pieces of paper.

PREPARATION:
Fill spray bottles with paint.

ACTIVITY:
Invite the children to create designs by "spray painting" on their papers with the spray paint bottles.

SENT IN BY: Cathryn Abraham, St. Charles, IL

SQUEEZE BOTTLES

MATERIALS:
Small squeeze bottles, tempera paints of various colors, construction paper.

PREPARATION:
Mix tempera paints to a thick consistency. Pour into squeeze bottles. Cut paper into a variety of shapes and sizes.

ACTIVITY:
Let the children squeeze paint on their papers to create designs.

SENT IN BY: Betty Ruth Baker, Waco, TX

"blot prints"

VARIATION: From Cynthia Holt, Danbury, CT
Squirt some paint inside pieces of folded paper. Have the children press outward with their hands on top of their papers. Then let them unfold their papers to reveal the designs they created.

"mural"

VARIATION: From B. Silkunas, Philadelphia, PA
Invite the children to create a mural by squirting paint from tempera-filled detergent bottles on a large sheet of butcher paper placed over newspapers or a drop cloth.

Painting with . . .

Q-TIPS

"painting tips"

MATERIALS:
Q-Tips, tempera paint, construction paper, egg cartons.

PREPARATION:
Assemble supplies. Cut egg cartons in thirds to make four-part paint containers. Pour small amounts of paint into each container.

ACTIVITY:
Have the children dip Q-Tips into paint and use them like brushes to create designs on their papers.

VARIATION:
Use dried wide markers in place of Q-Tips. Let the children dip them in paint and use them to draw or write.

SENT IN BY: Barbara H. Jackson, Denton, TX

HINT: From Gina Masci, Arlington, MA
To make cleanup easy and fun, fill a dish basin with a small amount of soapy warm water and place it at children's level. Let children wash their hands, then supply them with paper towels to dry their hands.

SIMILAR IDEA SUBMITTED BY:
B. Silkunas, Philadelphia, PA

SCOURING PADS

MATERIALS:
Large sheets of paper, plastic scouring pads, paint pans, liquid tempera paint, paper towels.

PREPARATION:
Place folded paper towels in paint pans and pour on liquid tempera to make paint pads.

ACTIVITY:
Let the children dip the plastic scouring pads into liquid tempera and use them to "paint" on their papers. Stroking motions or up and down movements create interesting effects. This is fun to do with two colors of paint.

SENT IN BY: Carolyn Tyson, Ann Arbor, MI

Painting with . . .

"dry tempera"

MATERIALS:

Construction paper, cotton balls, brushes, various colors of powdered tempera in margarine containers, hair spray.

ACTIVITY:

Let the children "paint" with the powdered tempera using cotton balls or brushes to smear the dry paint on their papers. When they have finished, spray each child's picture lightly with hair spray to set the paint.

HINT:

Q-Tips may also be used for "painting," but they require somewhat more refined small motor skills.

SENT IN BY: Cindy Dingwall, Palatine, IL

HINTS: From Nancy J. Heimark, Grand Forks, ND

Use meat trays or paper plates to hold the powdered paint. If using several colors, the trays can be passed around the table. If the room is small, or has poor ventilation, spray the paintings outside.

COTTON BALLS

"clothespin handles"

MATERIALS:

Spring-type clothespins, cotton balls, paint, small containers, paper, tape.

PREPARATION:

Pour paint into small containers. Tape paper to table. Clip a cotton ball to the end of each clothespin.

ACTIVITY:

Using the clothespins as handles, let the children dip the cotton balls into paint and then spread it on their papers.

HINT:

When the cotton balls start to get stringy from too much paint, replace them with fresh ones.

SENT IN BY: Gina Masci, Arlington, MA

Painting with . . .

A SCREEN

MATERIALS:

Colored construction paper, tempera paint, paint containers, old toothbrushes, wire screen attached to a cardboard box frame (see directions below), materials for making stencils.

PREPARATION:

For stencils, gather things such as leaves or flowers or cut paper shapes to fit themes such as animals, fruits or holidays. The shapes can be used many times, so only one or two sets are needed. Pour small amounts of tempera into containers and insert old toothbrushes.

ACTIVITY:

Have each child arrange stencil materials on a sheet of paper and place the paper under the framed screen. Then let the child rub a toothbrush dipped in paint back and forth over the screen. When enough paint has been spattered on the paper, remove the stencil materials and allow the painting to dry.

HINT:

Contrasting colors of paint and paper work best. White paint on dark colored construction paper, for example, is quite effective.

MAKING THE FRAME:

The time spent making a framed screen for spatter painting could be well worth it. It creates far less mess than using wooden sticks, it's easier for children to use independently and it will last for several years.

Purchase a piece of screen about 9"x12". The metal screen works better than plastic. Choose a sturdy cardboard box that has a bottom at least as large as the piece of screen and glue the flaps in the bottom together. Using a utility knife, remove the top flaps and cut around the sides of the box about 4" to 8" from the bottom. On one side, cut down another 2" or 3" to allow paper to be inserted without lifting frame. Cut a hole in the bottom of the box, at least 2" smaller on all sides than the piece of screen. Place the screen over the hole and use a staple gun to secure it to the box where it overlaps. To prevent children from getting scratched by the wire screen, staple an additional cardboard frame over the overlapping edges.

SENT IN BY: Ruth Engle, Kirkland, WA

"spatter painting"

Painting with . . .

MATERIALS:

Shoe box, tempera paint, shallow paint dish, toothbrush, construction paper, piece of wire screen, newspaper, leaves or other materials to use as stencils.

"leaf prints"

PREPARATION:

Cut construction paper into pieces slightly smaller than the shoe box. Pour paint into shallow dish. Spread newspaper on work table and place shoe box on top of it.

ACTIVITY:

For each child, place a piece of construction paper in the bottom of the shoe box and put a leaf on top of the paper. Place the screen on top of the box and mold it around the box edges, if necessary. Let the child dip the toothbrush in paint and rub it across the top of the screen until desired spattering effect is achieved. Remove the screen and take out the leaf along with the child's painting. Allow the painting to dry on a flat surface.

SENT IN BY: Betty Loew White, Columbus, OH

TONGUE DEPRESSORS

MATERIALS:

Cookie cutters or other simple forms, construction paper, styrofoam meat trays, sharp cutting knife, toothbrushes, tempera paint, tongue depressors.

PREPARATION:

Hold cookie cutters or other forms on styrofoam trays and cut around them with a sharp knife to make stencils.

"cookie cutter shapes"

ACTIVITY:

Have the children place styrofoam stencils on construction paper. Then let them dip toothbrushes in paint and rub tongue depressors across the toothbrushes to spatter paint onto their papers. Use Christmas or Thanksgiving cookie cutters for holiday pictures.

SENT IN BY: Barbara Robinson, Glendale, AZ

MARBLES

"designs"

"kites"

"flowers"

"mittens"

"holiday shapes"

MATERIALS:

Aluminum pie tins, one or two marbles per child, one or two colors of fairly thick paint, shallow paint containers, paper, smocks.

PREPARATION:

Cut paper circles to fit in the bottoms of the pie tins. Pour paint in containers and add marbles.

ACTIVITY:

Have the children place paper circles in their pie tins. Then put one or two paint-covered marbles in each tin. Let the children roll the marbles back and forth. The marbles will leave a trail of color, crisscrossing over and over again. This is a great eye-hand activity.

SENT IN BY: Melode Hurst, Grand Junction, CO

VARIATION: From Myrna Andres, Manassas, VA

Use rectangular paper placed in the bottom of shallow cardboard boxes for marble painting. Small plastic balls can be used in place of the marbles.

VARIATION: From Jane Spannbauer, So. St. Paul, MN

Cut construction paper into kite, flower or butterfly shapes and use them for marble painting.

VARIATION: From Nancy Heimark, Grand Forks, ND

Cut down half-gallon milk cartons to use as paper holders. Let the children marble paint on precut seasonal shapes such as pumpkins, bells, mittens and hearts.

VARIATION: From Connie Gillilan, Hardy, NE

Instead of putting marbles in the paint, put one or two teaspoons of tempera on each paper and let the children roll the marbles back and forth over the paint.

Painting on . . .

SNOW

MATERIALS:

Watercolors, tempera paint or food coloring mixed with water, brushes, paint containers, snow.

PREPARATION:

Pour paint into containers suitable for use outdoors.

"colorscapes"

ACTIVITY:

Take the children outside when the snow is a few inches deep. Allow them to freely explore the effects of paint on snow, using both small and large brushes. The colors will spread as the paint touches the snow. Encourage creating splashed colors with wide, sweeping movements or making snow sculptures and painting them. The snow will hold the paint cans and brushes firmly in place, so you won't need to worry about upsets.

"sculptures"

SENT IN BY: Jan Goldstein, Indianapolis, IN

VARIATION: From Marjorie Debowy, Stony Brook, NY

Fill empty plastic squeeze bottles with water and different colors of food coloring. Let the children squirt the colors onto the snow. Watch the excitement as the snow becomes a rainbow of colors! The next day, examine the snow to observe the melting process.

"rainbows"

PAPER SHAPES

"pumpkins"

"hearts"

"flowers"

"shamrocks"

"Easter eggs"

MATERIALS:
Butcher paper or other painting paper, tempera paint, brushes, paint containers.

PREPARATION:
Cut desired large shapes from paper. These may be simple geometric shapes, holiday shapes such as pumpkins, Christmas trees, hearts, shamrocks or eggs, or other shapes such as flowers, butterflies or children.

ACTIVITY:
Let the children paint their shapes in any fashion desired. Easels can be used, or painting can be done at tables or even on the floor. One or several colors of paint may be provided with a brush for each color.

HINTS:
If you cut out paper children shapes, it might be fun to let each child use one to paint a picture of himself or herself. Display the finished paintings on a wall along with the children's names and photographs.

Use small peanut butter jars for paint containers. They have wide mouths and don't tip over as easily as plastic containers when inserted in a utility tote. Use the tote when painting at tables or on the floor.

SENT IN BY: Ruth Engle, Kirkland, WA

VARIATION: From Cindy Dingwall, Palatine, IL
Mix tempera paints in various shades of one color, depending on the theme of the shapes: reds and pinks for Valentine's Day, greens for St. Patrick's Day, etc.

Painting on . . .

MATERIALS:

Cardboard egg cartons, pipe cleaners, crayons or paint.

PREPARATION:

Cut egg cartons in half lengthwise.

ACTIVITY:

Egg cartons are perfect for making "caterpillars." Help the children fold pipe cleaners in half and poke them into the top of the first section of their egg carton halves to make antennas. Then let the children color eyes and designs on their caterpillars with crayons or paint.

SENT IN BY: Cathy Phillips, Clarkston, MI

"caterpillars"

MASKING TAPE

"white designs"

MATERIALS:

Shiny fingerpaint paper, masking tape, watercolor paints, brushes, small containers of water.

PREPARATION:

Put pieces of masking tape on each child's paper in any design. More advanced children may be able to put the tape on their own papers.

ACTIVITY:

Let the children paint their entire papers with watercolors. When the papers are dry, help the children carefully pull off the tape. The white lines that appear will separate the colors, creating interesting designs.

SENT IN BY: Nancy J. Heimark, Grand Forks, ND

Painting on . . .

NEWSPAPER

MATERIALS:

Newspaper, tempera paint, brushes, paint containers.

PREPARATION:

Pour paint into containers. Place newspaper in desired painting areas.

ACTIVITY:

Let the children paint pictures or designs on newspaper. Try a variety of painting areas around the room: easels, tables, walls and floor.

SENT IN BY: Cynthia Holt, Danbury, CT

MATERIALS:

Oaktag or light cardboard, tempera paint, white liquid glue, brushes, paint containers, aluminum foil, newspaper.

PREPARATION:

Cover table with newspaper. Cut large rectangles out of oaktag and cover with aluminum foil. In paint containers, mix paint with glue to a thick consistency. Stir well.

ACTIVITY:

Have the children paint designs on the aluminum foil with colored glue. The effect is nice if areas are left unpainted, since the foil reflects the paint.

HINTS:

When finished, make frames for the paintings. This is a nice activity for Christmas because of the shiny effect. Older children can etch designs in the glue with popsicle sticks, either freehand or using stencils.

SENT IN BY: Jane Yeiser Woods, Sarasota, FL

FOIL

"shiny pictures"

Painting on . . .

ROCKS

MATERIALS:

Rocks, paint, small containers, brushes.

PREPARATION:

Before doing the activity, take your children on a walk to gather rocks that can be painted. Pour paint into small containers.

ACTIVITY:

Let the children paint the special rocks that they found any way they wish.

HINT:

As a separate activity, have the children wash their rocks before they paint them. Toothbrushes work very well for this.

SENT IN BY: Gina Masci, Arlington, MA

PINECONES

"Christmas trees"

MATERIALS:

One large pinecone for each child, green and white tempera paint, small sponges, glitter, small Christmas balls (optional), newspaper.

PREPARATION:

Pour tempera into shallow dishes. Cover tables with newspaper.

ACTIVITY:

Have the children dip sponges into green and white tempera and apply paint all over their pinecones to simulate snow-covered evergreen trees. While paint is still wet, glitter may be sprinkled on, or small Christmas balls may be added.

HINT:

Children who do not like messy hands can paint with sponges that are clipped to clothespins.

SENT IN BY: Kathy Sizer, Tustin, CA

Painting on . . .

PAPER PLATES

"suns"

MATERIALS:

Paper plates, yellow paint, brushes, yellow crepe paper or tissue paper, glue.

PREPARATION:

Cut crepe or tissue paper into small rectangles, approximately 1" x 2".

ACTIVITY:

Have the children paint their paper plates yellow to make "suns." While the plates are still wet, let the children press paper rectangles on the paint. They should stick, but if the paint dries before the children have finished, let them use glue. Encourage the children to not only stick rectangles in the middle of their plates, but also over the rims to resemble sun rays.

VARIATION:

Have your children glue sunflower seeds on the middle of their plates to turn their suns into sunflowers. Attach them to green paper stems to create a sunflower "garden."

"sunflowers"

VARIATION:

After your children have painted their paper plates yellow and the paint has been allowed to dry, have the children draw lines or paste precut shapes on their plates to make "happy faces."

"happy faces"

CARDBOARD

MATERIALS:

Large cardboard cartons, poster paint, 2-inch brushes, newspaper.

PREPARATION:

Collect cartons such as large appliance boxes or food cartons from supermarkets. Put newspaper in work area.

ACTIVITY:

This activity can be done inside or out. Give each child a cardboard carton, or plan this as a group project, and let the children paint the cartons any way they wish. Your children will have fun using their painted cartons, especially those that are large enough to crawl into.

"box painting"

SENT IN BY: Cynthia Holt, Danbury, CT

Painting on . . .

MATERIALS:

Construction paper, glue in squeeze bottles, tempera paint, brushes.

PREPARATION:

Twenty-four hours ahead of time, squeeze glue on a paper for each child in a pattern of your choice. Do not rub the glue. Just allow it to dry as it was squeezed on the paper.

ACTIVITY:

Hand out the papers and let your children paint over the glue patterns. The glue provides a new, interesting texture for them to work with.

VARIATION:

Depending upon the ability of the children, you might want to let them squeeze the glue on their own papers.

SENT IN BY: Kathleen Tobey-Arney, Griffith, IN

GLUE

"designs"

VARIATION: From Mary Haynes, Lansing, MI

Have your children dribble rubber cement on their papers. Allow the glue to dry about half an hour. Next, have the children paint over the glue. When the paint has dried, let the children peel off the rubber cement, revealing the pictures or designs they have made.

CRAYON

"ghosts"

"stars"

"clouds"

"fish"

MATERIALS:

Paper, black paint, white crayons.

PREPARATION:

Thin the black paint. Using a white crayon, draw a "mystery picture" on paper for each child. Suggestions: Fall — ghosts; Winter — stars, moons, hearts; Spring — clouds; Summer — fish. Older children may be able to draw their own pictures.

ACTIVITY:

Let your children paint over their "mystery pictures" with the thinned black paint.

Painting on . . .

STENCILS

"simple shapes"

MATERIALS:
Cardboard or oaktag, tempera paint, brushes or sponges, construction paper, masking tape, shallow dishes, newspaper.

PREPARATION:
Make a stencil for each child by cutting a simple shape such as a triangle, square or daisy from the center of a piece of cardboard. Place a piece of construction paper under the stencil and tape them both to a table. Pour paint into shallow dishes.

ACTIVITY:
Let each child dab paint over the open area of the stencil. Remove stencil and place painting on newspaper to dry. Other colors may be stenciled onto the same picture when the first color has dried.

SENT IN BY: Betty Loew White, Columbus, OH

"Easter eggs"

"cars"

VARIATION: From Lois Olson, Webster City, IA
Cut Easter egg shapes from thin cardboard such as potato chip boxes. Attach loops of tape, sticky side out, to the backs of the shapes and stick them on sheets of paper. Let the children brush thinned paint around the edges of their shapes, extending out about an inch. It's not necessary for them to paint their shapes, but they probably will. Remove the cardboard shapes, leaving unpainted egg shapes in the middle of the papers. When the papers are dry, let the children decorate their egg shapes with crayons, if desired.

VARIATION: From Lois Olson, Webster City, IA
Follow the same procedure to make car, bus and airplane shapes to be used for a transportation unit. This method is similar to spatter painting, but it goes faster and is less messy.

VARIATION: From Carole Hardy, Pittsburgh, PA
Cut out flower shapes, trees, cars or geometric shapes to make stencils and tape them on large sheets of white paper. Then let the children shade over the edges of their stencils using the sides of peeled crayons.

SIMILAR IDEA SUBMITTED BY:
Cathryn Abraham, St. Charles, IL

"flowers"

"trees"

GLUING

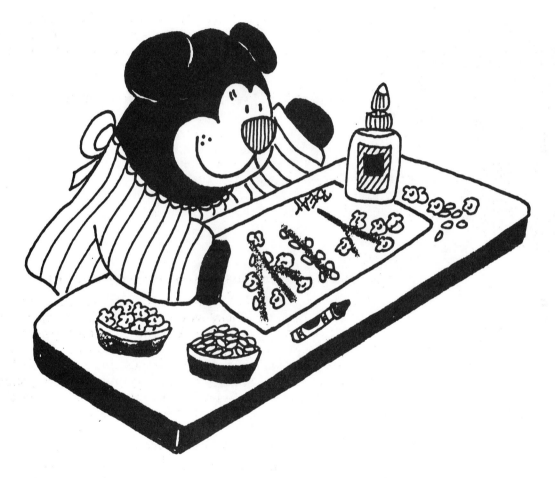

Gluing . . .

COLLAGE MATERIALS

MATERIALS:

Background material such as paper, railroad board, wood, paper plates or plastic lids; collage materials such as paper, lace, ribbon, paper doilies, magazine pictures, stickers, shapes cut from giftwrap, small pebbles, pinecones, shells, seeds, dried flowers or grasses, artificial flowers, macaroni, cotton balls or dyed eggshell pieces; margarine tubs or styrofoam trays, glue or paste, glue containers, brushes, popsicle sticks, paper towels.

PREPARATION:

Cut background into shapes, if desired. Gather appropriate collage materials and sort them into styrofoam trays or margarine tubs.

ACTIVITY:

For each child, brush a piece of background material with a thinned solution of white glue. Or provide each child with a container of glue and a brush or a dab of paste on a folded paper towel and a popsicle stick applicator. Then let the children glue collage materials on their backgrounds any way they wish. Note that for heavier objects or those without flat surfaces such as pebbles, pinecones, popcorn or shells, glue might best be applied from squeeze bottles, although young children will need close supervision with this kind of gluing. Another alternative would be to let children dip the objects into glue placed in shallow containers.

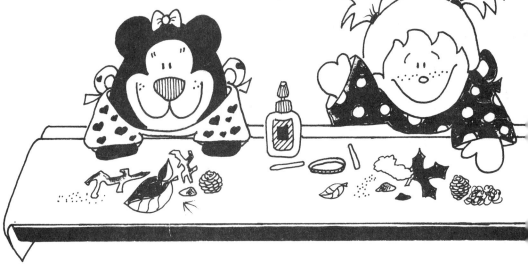

VARIATION:

Cut out large paper heart shapes. Let the children glue on things such as lace, ribbon, paper doilies, hearts cut from colored paper, giftwrap or fabric, artificial or dried flowers or pieces of red, pink or white tissue paper.

"Valentine collages"

Gluing . . .

COLLAGE MATERIALS

VARIATION

Collect things on a fall walk such as colored leaves, pinecones, twigs, moss and small pebbles. Let the children glue the objects on precut paper or cardboard leaf shapes or on a large sheet of butcher paper which can be mounted on a wall later for viewing and enjoying.

"nature collages"

"texture collages"

VARIATION:

Provide the children with a variety of things that have different textures such as cotton balls, sandpaper or textured fabric scraps. Let them glue the items on heavy backgrounds such as paper plates or cardboard.

"Thanksgiving collages"

VARIATION:

Draw turkey shapes on pieces of brown paper and provide the children with feathers to glue on the turkey bodies. Use feathers from an old feather pillow.

SENT IN BY: Ruth Engle, Kirkland, WA

"Presidents' Day collages"

VARIATION: From Kathy Sizer, Tustin, CA

Make red, white and blue collages for Presidents' birthdays or the Fourth of July. Include red, white and blue striped wrapping paper or crepe paper, star shapes and flag stickers. Celebrate a "Red Day" or a "Blue Day" when you make the collages, and have everyone dress in the appropriate color. You might even include the same color of food in your snack for the day.

41

Gluing . . .

COLLAGE MATERIALS

"Christmas bags"

VARIATION: From Kathy Sizer, Tustin, CA

At Christmas time, let the children decorate the sides of large grocery sacks by gluing on things such as bits of wrapping paper, ribbon, yarn, cellophane, tinsel, Christmas pictures, stickers and red and green fabric. These are nice for using at home on Christmas morning to keep small opened gifts from getting lost in the shuffle. A family might make a bag for everyone who will be present for the gift-opening. This allows even tiny two-year-olds to see that they have made something useful for the Christmas celebration.

"Christmas trees"

VARIATION: From Kathy Sizer, Tustin, CA

Give each child a large green paper triangle shape to use as a base for gluing on Christmas materials similar to those listed in the activity above.

VARIATION: From Mrs. David Zucker, Reno, NV

Cut out the first letter of each child's name from a large piece of paper. Allow the children to paint their letters. When the paint is dry, the children can paste a variety of things on their letters, thus creating personalized collages. Let each child choose a special place to hang his or her letter collage.

"letter collages"

Gluing . . .

COLLAGE MATERIALS

"butterflies"

MATERIALS:
White or colored paper to fit ditto machine, small scraps of colored paper, yarn or cloth, glue or paste.

PREPARATION:
Ditto a butterfly outline on white or colored paper for each child.

ACTIVITY:
Let the children choose scraps of colored paper, yarn and other items to decorate their butterflies. Have them glue or paste the items, then stick the items on their butterfly shapes.

HINT:
The butterflies can be cut out either before or after decorating.

SENT IN BY: Sr. Mary Bezold, Melbourne, KY

"holiday shapes"

VARIATION: From Ann Herold-Short, Rushville, IN
Use photocopied outlines of holiday shapes such as hearts, Christmas trees, stars or shamrocks and let the children paste on small bits of colored paper.

Gluing . . .

WALLPAPER SHAPES

MATERIALS:

Light colored paper, scraps of wallpaper and other colored papers, crayon or felt marker, paste.

PREPARATION:

Using a crayon or felt marker, draw a simple clothesline on light colored paper for each child. Cut clothing shapes out of wallpaper and other colored paper scraps and add details with a felt marker.

"clotheslines"

ACTIVITY:

Hand out the papers and let the children paste clothing shapes on their clothelines.

HINT:

Pasting is hard for young children. For their first experience, let them place pre-pasted shapes on paper. The next time, have them spread lumps of paste that you have applied. Then, when they are ready, let them apply and spread the paste and place the shapes on paper themselves. It takes lots of practice.

SENT IN BY: Sally J. Horton, Waukegan, IL

"patchwork designs"

VARIATION:

Give each child a piece of construction paper folded into small squares. Cut wallpaper scraps into matching squares. Then let the children glue the wallpaper squares on their papers to create patchwork designs.

Gluing . . .

PAPER SQUARES

"Indian corn"

MATERIALS:

Manila paper, black felt marker, paste, scraps of colored paper.

PREPARATION:

On manila paper, draw a large ear of corn with the shucks peeled halfway back (like a banana) for each child. Add kernels by drawing a "brick-wall" design in the exposed half. Cut tiny pieces of colored paper the same size as the kernels.

ACTIVITY:

Have the children paste the small paper kernels onto their corncob shapes. Shade shucks lightly with green and brown chalk, if desired.

HINTS:

Either pre-paste the colored paper kernels or dot paste on the children's corncobs. Most two-year-olds will not care to paste on more than six to ten kernels. Have some real Indian corn on hand to show the children.

SENT IN BY: Sally J. Horton, Waukegan, IL

Gluing . . .

PAPER SHAPES

"holiday symbols"

MATERIALS:

One sheet of black construction paper for each child, construction paper in other colors and shades, glue or paste.

PREPARATION:

Cut holiday shapes from construction paper: different sized hearts from red and pink paper; different sized shamrocks from various shades of green paper, etc.

ACTIVITY:

Give each child a piece of black paper and a number of shapes in different sizes and shades. Let the children make collages by gluing or pasting their shapes on the black paper.

SENT IN BY: Cindy Dingwall, Palatine, IL

MATERIALS:

Green and blue construction paper, glue.

PREPARATION:

Cut triangles of different sizes from green construction paper.

ACTIVITY:

Have the children paste the green triangles on blue paper to create Christmas tree "forests." Different shades of green make the pictures more attractive.

SENT IN BY: Sally J. Horton, Waukegan, IL

PAPER SHAPES

"Christmas forests"

VARIATION:

Try brushing some glue on the construction paper and sprinkling with salt or glitter to make snow.

Gluing . . .

PAPER SHAPES

MATERIALS:

One sheet of 8½" x 11" white paper for each child, construction paper, glue, crayons or pencils.

"shape pictures"

PREPARATION:

Cut construction paper into various shapes such as squares, circles, triangles, rectangles, ovals and semicircles.

ACTIVITY:

Have the children arrange various construction paper shapes on their white papers to make people, animals, cars or whatever else they would like. Next, have them glue each piece of construction paper in place. When they have finished, let them add features and background with more paper, crayons or pencils.

SENT IN BY: Carole Hardy, Pittsburgh, PA

VARIATION: From Kathleen Tobey-Arney, Griffith, IN

Cut triangle shapes out of green construction paper. Give several to each child and allow time for him or her to arrange the triangles on a piece of paper in the shape of a Christmas tree. Have the children paste their triangles on their papers. Colored paper circles can then be added to decorate their trees.

"Christmas trees"

Gluing . . .

PAPER SHAPES

"Easter collages"

MATERIALS:
Colored construction paper, whole and scraps, paste.

PREPARATION:
Cut various Easter shapes such as bunnies, crosses, baskets and eggs out of construction paper.

ACTIVITY:
Let the children paste Easter shapes on paper any way they wish. Or, tear crosses from brown paper and have the children paste them on their papers along with two egg shapes and a rabbit shape to make dramatic pictures that will help them associate familiar symbols of Easter with the true meaning of the holiday.

SENT IN BY: Sally J. Horton, Waukegan, IL

PAPER SHAPES

"flowers"

"kites"

MATERIALS:
Construction paper in pastel colors, glue, crayons or felt markers.

PREPARATION:
Cut heart, circle or square shapes from construction paper for each child.

ACTIVITY:
Let the children paste shapes on their papers in any design they wish. Add stems and leaves with a crayon or felt marker to make the shapes into flowers. Or, leave off the leaves and you can use this idea to make kites or balloons in a sky.

SENT IN BY: Sally J. Horton, Waukegan, IL

Gluing . . .

MATERIALS:

Old Christmas cards, giftwrap paper, white tissue paper, construction paper, paste or glue.

PREPARATION:

Give each child a large piece of tissue paper. Cut Christmas shapes from old cards, giftwrap paper or construction paper.

ACTIVITY:

Have the children paste shapes on the tissue paper. Name each shape as the children paste and tell, very simply, why it is associated with Christmas. The children love working with these bright materials.

"Christmas collages"

HINT:

Tissue paper is quite flimsy, so you may wish to back it by pasting it to construction paper or cardboard.

SENT IN BY: Sally J. Horton, Waukegan, IL

VARIATION: From Kathleen Tobey-Arney, Griffith, IN

Let the children use old Christmas cards to cut apart and arrange in collages. They love looking through cards and picking out the ones they like best.

Gluing . . .

PICTURE CUTOUTS

"theme collages"

MATERIALS:

Construction paper, pictures from catalogs, magazines and giftwrap that depict desired theme, white glue.

PREPARATION:

Assemble and cut out pictures that illustrate desired theme such as bears, spring flowers or farm animals.

ACTIVITY:

Let each child glue his or her choice of theme pictures all over a construction paper background.

HINTS:

Collages are wonderful! No one can fail, and they provide lots of vocabulary-building items to talk about. Background paper may be cut into theme shapes such as simple flowers or Easter eggs.

SENT IN BY: Kathy Sizer, Tustin, CA

VARIATION:

Let each child cut out magazine pictures that contain the same dominant color and then glue them on a piece of construction paper of the same color.

"color collages"

VARIATION: From Ruth Engle, Kirkland, WA

Let children select magazine pictures to represent a specific classification such as Foods I Like, Happy Faces, Animals, Flowers, or My Family. Then have them glue pictures to an appropriate background such as paper plates for foods or house shapes for members of the family.

Gluing . . .

MATERIALS:

Paper plates, magazine pictures of faces, paste, crayons.

PREPARATION:

Cut eyes, noses and mouths from magazine pictures of faces.

ACTIVITY:

Invite each child to duplicate his or her own face by selecting eyes, a nose and a mouth and pasting them in the appropriate places on a paper plate. Add details such as hair and freckles with crayons.

VARIATION:

Invite each child to create family members' faces.

SENT IN BY: B. Silkunas, Philadelphia, PA

PICTURE CUTOUTS

"face parts"

PICTURE CUTOUTS

"color books"

MATERIALS:

Several different colors of construction paper, old magazines and catalogs, glue, stapler.

PREPARATION:

For each child, staple several different colors of construction paper together to make a book. Let the child pick the colors.

ACTIVITY:

Hand out magazines and catalogs and ask the children to look for colored pictures that match the colors of the pages in their books. Then let them tear out the pictures and paste them on the appropriate book pages: blue pictures on blue pages, red pictures on red pages, etc. The children will need adult supervision while making their color books.

SENT IN BY: Kathleen Tobey-Arney, Griffith, IN

Gluing . . .

PAPER CIRCLES

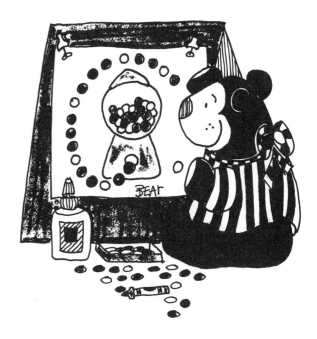

MATERIALS:

Oaktag, colored construction paper, glue, crayons.

PREPARATION:

For each child, cut a gum ball machine shape out of oaktag along with a number of small paper circles to use as gum balls.

ACTIVITY:

Have the children color their gum ball machine shapes with crayons. Let them choose the circles they want for the gum balls and glue them on their shapes.

HINT:

If you are working on a particular color, cut all the circles out of that color of construction paper.

SENT IN BY: Valerie Bielsker, Lenexa, KS

"gum balls"

VARIATION:

Colored stickers could also be used to represent gum balls.

Gluing . . .

MATERIALS:

Construction paper, twigs, red self-stick dots or small paper circles, white glue.

PREPARATION:

Glue one or more twigs onto a piece of construction paper for each child.

ACTIVITY:

Let the children affix red self-stick dot "cherries" all over their papers, some as if growing on the twigs and others as if falling off. Even though this is a simple activity, the children will feel very successful!

SENT IN BY: Kathy Sizer, Tustin, CA

CIRCLE STICKERS

"cherry trees"

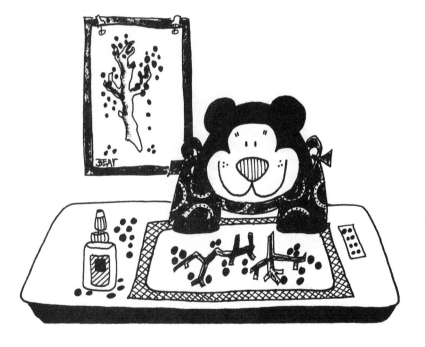

53

Gluing . . .

TORN PAPER

"rainbows"

MATERIALS:

Butcher paper, several different colors of yarn, construction paper that matches yarn colors, glue, crayons (optional).

PREPARATION:

On pieces of butcher paper, draw arched lines to represent rainbows.

ACTIVITY:

Put glue on the rainbow lines and let the children place a piece of different colored yarn along the entire length of each line. Have the children tear the colored paper into pieces, one color at a time. Then have them glue the torn paper onto the area between the pieces of yarn, under the yarn for that color. Encourage them to fill the entire space with the appropriate colored paper pieces. You may want to color a portion of each space with a crayon to show the children where to put the torn paper.

SENT IN BY: Valerie Bielsker, Lenexa, KS

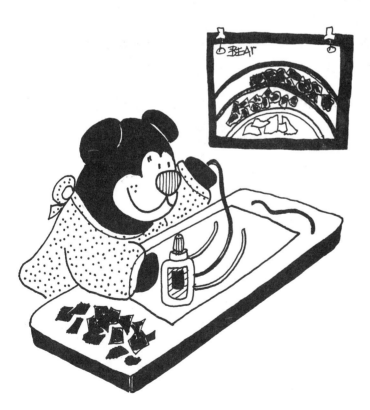

Gluing . . .

MATERIALS:

9"x12" sheets of black and white construction paper, paste, scissors, black felt pens.

ACTIVITY:

Have the children each cut or tear a ghost-like shape out of white construction paper, beginning at one corner and working to the middle of the top and then down to the corner of the other side. Encourage all attempts to make wiggly shapes, as some children will find this easier to do than others. Then have the children paste their white shapes on black construction paper and add eyes with a black marking pen. This can become a favorite art project for your children. It is the simplicity of the activity that allows each child to succeed in making an adorable ghostly goblin!

"ghostly goblins"

SENT IN BY: Jane M. Spannbauer, So. St. Paul, MN

PAPER STRIPS

"chains"

MATERIALS:

Old magazines with slick pages, scissors, paste.

PREPARATION:

Tear colorful pictures from magazines and cut them into 1"x7" strips.

ACTIVITY:

Show the children how to paste the ends of a paper strip together to make a loop. Then help them to make chains by inserting one paper strip at a time into a loop and again pasting the ends together. Using the slick magazine paper is especially helpful when young children are making chains for the first time, since it's easier to paste than construction paper.

SENT IN BY: Jean L. Woods, Tulsa, OK

Gluing . . .

TISSUE PAPER

"Christmas wreaths"

MATERIALS:
7-inch paper plates, glue, red and green tissue paper, red ribbon, green yarn, hole punch, a photograph of each child (optional).

PREPARATION:
Cut the centers out of the paper plates, leaving the rims to use as wreath bases. Cut the red and green tissue paper into 1-inch squares.

ACTIVITY:
Have the children glue crumpled green tissue paper squares all over their paper plate rims. Then have them glue small clumps of red tissue in three different places on the rims to make "berries." When they have finished, glue a red ribbon bow at the bottom of each wreath. Then punch a hole in the top of the wreath and tie a loop of green yarn through it for hanging. If you wish, tape a photograph of the child to the back of the plate so that his or her face appears in the center of the wreath. A second paper plate may be used to cover the back.

SENT IN BY: Barbara Dunn, Hollidaysburg, PA

VARIATION: From Kathy Sizer, Tustin, CA

Instead of cutting green tissue paper into squares, tear it into small pieces and let the children glue the pieces on their paper plate rims. Make "berries" for the children to glue on their wreaths by punching circles out of red construction paper with a hole punch.

Gluing . . .

MATERIALS:

Construction paper, tissue paper in one color or assorted colors, liquid starch or white glue thinned with water, brushes.

PREPARATION:

Tear pieces of tissue paper into 2-inch or 3-inch pieces. Cut construction paper into holiday shapes, if desired. Thin glue if not using liquid starch.

"collages"

ACTIVITY:

Have the children brush liquid starch or thinned glue on construction paper and stick on pieces of torn tissue paper. Then have them brush more starch or glue on top of the tissue pieces. The children may cover their entire papers with overlapping tissue pieces or leave areas of the construction paper uncovered.

"holiday shapes"

HINTS:

Try black construction paper under various colors of tissue. This makes the colors look vivid when dry. Seasonal color choices, such as fall colors, may be used without cutting background into special shapes.

SENT IN BY: Kathy Sizer, Tustin, CA

"fall leaves"

VARIATION: From Kathy Monahan, Breckenridge, MN

Cut red, yellow and orange tissue paper into 1-inch squares to use as fall leaves. Have each child make a tree trunk on paper using his or her arm as a pattern, or make a trunk for the child. Then have the child glue leaves on the paper, some on the tree branches, some falling from the tree and some on the ground.

Gluing . . .

COTTON BALLS

"spring blossoms"

MATERIALS:

White construction paper, cotton balls, crayons, glue, glue containers.

PREPARATION:

If your children are under three, draw several branches with crayon on a piece of white construction paper for each child. Older children can draw their own branches.

ACTIVITY:

Let the children dip cotton balls in glue and place them on their branches. Have them continue the procedure until each branch contains several "blossoms."

SENT IN BY: Susan Roberts Bolash, Bethlehem, PA

MATERIALS:

Light blue construction paper, cotton balls, glue, small brushes or Q-Tips.

ACTIVITY:

Let the children use brushes or Q-Tips to spread glue across their papers. Then have them stretch out two or three cotton balls and lay them on top of the glue to create "clouds."

HINT:

It might be wise to have your children wash their hands between spreading the glue and working with the cotton balls.

COTTON BALLS

"clouds"

VARIATION: From Cathy J. Kriebs, Dubuque, IA

Older children might enjoy gluing on precut kite shapes which have been glued to styrofoam pieces (gives a 3-D effect). They can also add strings to the kites.

Gluing . . .

COTTON BALLS

MATERIALS:
White construction paper, cotton balls, glue.

PREPARATION:
Cut a lamb shape for each child from construction paper.

ACTIVITY:
Have the children glue cotton balls onto their lamb shapes.

HINT:
Talk about the nursery rhyme, "Mary Had A Little Lamb."

SENT IN BY: Deborah Balmer, Mesa, AZ

"woolly lambs"

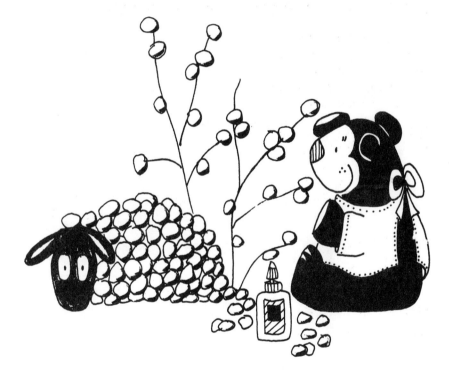

COTTON BALLS

MATERIALS:
Oaktag, cotton balls, large and small circle patterns, black paper, glue.

PREPARATION:
Use the circle patterns to draw two circles on oaktag for each child. Glue the small circles on top of the large ones to make snowmen. Cut black paper into shapes to use as eyes, noses, mouths, hats and scarves.

"snowmen"

ACTIVITY:
Have the children glue cotton balls all over their snowmen. Then let them glue on black paper eyes, noses, mouths, hats and scarves.

SENT IN BY: Valerie Bielsker, Lenexa, KS

Gluing . . .

COTTON BALLS

"winter hats"

MATERIALS:

Construction paper, paste, crayons, paint, brushes, cotton balls.

PREPARATION:

Draw a stocking cap shape for each child on a piece of construction paper. A half circle with a cuff across the bottom and a tassel at the top is simple to do. Cut out shapes.

ACTIVITY:

Have the children decorate their cap shapes with crayons or paint or by pasting on scraps of colored paper. (Sponge painting also works well for this project.) Let them each paste a cotton ball on the tassel area. While the children are working, talk about the changing weather and how hats help keep heads and ears warm. The children may also want to make mittens to match their caps. Together they make a great bulletin board display to remind parents that it is time to dress the children in warmer clothes for outdoor play.

SENT IN BY: Sally J. Horton, Waukegan, IL

"mittens"

VARIATION:

As an added touch, let each child glue a piece of string to his or her mittens to hook them together.

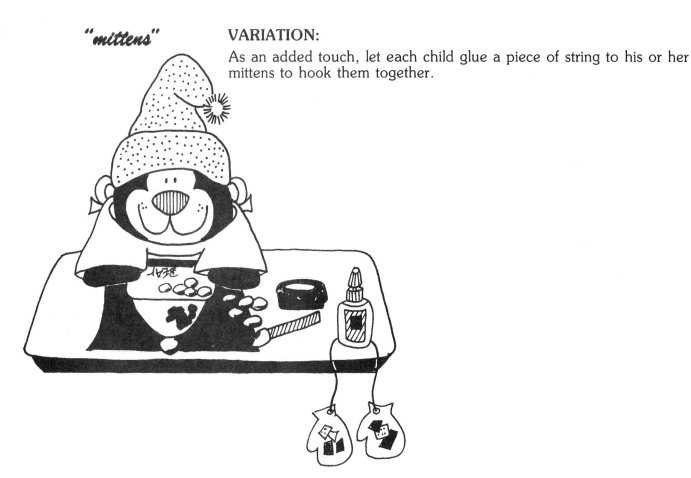

60

Gluing . . .

COTTON STUFFING

MATERIALS:
Construction paper of various colors, cotton pillow stuffing, glue or paste.

PREPARATION:
Trace a bunny shape on construction paper for each child. Use a variety of colors. Then for each child, cut out a pair of pink construction paper ears and a pair of blue construction paper eyes.

ACTIVITY:
Have the children pull the cotton stuffing apart into soft, fluffy pieces and paste or glue them onto their traced bunnies. When their entire shapes are filled, they can then glue on the bunny eyes and ears.

SENT IN BY: Jane M. Spannbauer, So. St. Paul, MN

"fluffy bunnies"

VARIATION:
Precut bunny shapes can also be used with younger children.

Gluing . . .

DRY LEAVES

"fall leaves"

MATERIALS:
Green construction paper, dry fall leaves picked up from the ground, glue, brushes.

PREPARATION:
Cut a fairly large leaf shape from construction paper for each child.

ACTIVITY:
Have the children brush glue on their leaf shapes. Then let them crinkle dry leaves and scatter the pieces all over the glue.

SENT IN BY: Deborah Balmer, Mesa, AZ

VARIATION: From Cathy Phillips, Clarkston, MI
Draw bare tree figures on pieces of construction paper. Then let the children crumple up the dry leaves and glue the pieces on their papers.

CUPCAKE LINERS

MATERIALS:
Construction paper, cupcake liners, paste, crayons.

ACTIVITY:
Invite the children to paste cupcake liners, facing outward, on construction paper to represent flowers. Then help them add stems and leaves to their flowers with crayons.

SENT IN BY: B. Silkunas, Philadelphia, PA

"flowers"

Gluing . . .

BUTTONS

"cars & trucks"

MATERIALS:

Large sheets of construction paper, four colors of construction paper scraps, old buttons, about 1 inch in diameter, glue, small margarine tubs, small brushes, felt marker.

PREPARATION:

For each child, cut out four different colored shapes of cars and trucks, including the wheel shapes. On each large piece of construction paper, draw a road with a felt marker. Provide each child with glue in a little margarine tub along with a small brush.

ACTIVITY:

Have each child glue car and truck shapes onto his or her "road." Then let the child pick from a variety of buttons to glue on the shapes as wheels. Two-year-olds like the three-dimensional look and feel that the buttons give. At the same time, they are learning that wheels help cars and trucks to move on roads.

SENT IN BY: Brenda MacQuilliam, Crownsville, MD

"overalls"

VARIATION: From Kathy Sizer, Tustin, CA

Cut overalls shapes out of construction paper and let the children glue on buttons. The buttons can be glued in the usual places as well as all over the shapes to make button collages. Large self-stick dots can also be used, if desired.

Gluing . . .

EGG SHELLS

"Easter bunnies"

MATERIALS:

Construction paper, eggshells, glue, felt marker, food coloring (optional).

PREPARATION:

Save eggshells and crush them. They can be dyed with food coloring, if desired. Use a felt marker to draw bunny outlines on construction paper.

ACTIVITY:

Have the children spread glue inside their bunny outlines. Then let them scatter crushed eggshells on top of the glue and shake off the excess.

HINT:

Use masking tape to secure the papers to the table. This avoids the frustration involved with papers that keep moving. In addition, the masking tape is already in place, so pictures can easily be retaped to a wall for display.

SENT IN BY: Nancy J. Heimark, Grand Forks, ND

"Easter eggs"

VARIATION: From Sally J. Horton, Waukegan, IL

Cut egg shapes from construction paper and cover with glue. Have the children spinkle eggshells over the egg shapes like glitter. These make nice Easter greeting cards.

Gluing . . .

SHELLS

MATERIALS:

Small, flat pieces of driftwood, assortment of small shell pieces and beach rocks, glue bottles, glue mats, trays.

PREPARATION:

Prepare table with glue mats and small glue bottles for each child. (Glue mats can be made by covering heavy paper with contact paper.) Fill trays with wood, shell pieces and rocks.

ACTIVITY:

Have each child select a piece of wood, or perhaps a rock, as a base along with favorite beach rocks and shell pieces. Let the child experiment with the amount of glue that must be squeezed out to hold a particular shell piece or rock onto the base. Encourage the child to press and wait as each new part is added to his or her creation.

HINTS:

Small rocks and shell pieces work best. Wood should be as flat as possible.

SENT IN BY: Lanette L. Gutierrez, Olympia, WA

VARIATION: From Sr. Mary Bezold, Melbourne, KY

Use pieces of formica as bases for the collages. These can be used as plaques or wall hangings.

Gluing . . .

FEATHERS

"ducks"

MATERIALS:

Yellow construction paper, yellow feathers (available at crafts stores), glue, brushes.

PREPARATION:

Cut a duck shape from yellow construction paper for each child.

ACTIVITY:

Have the children brush glue over their duck shapes. Then let them stick feathers on the glue.

VARIATION:

Let the children glue brown feathers on turkey shapes or white feathers on chicken shapes.

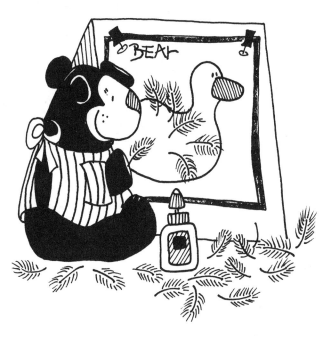

GLITTER

"hearts"

MATERIALS:

Fingerpaint paper, red fingerpaint, white liquid glue, paintbrushes, glitter.

ACTIVITY:

Have the children use red paint to fingerpaint designs on their papers. When the papers have dried, cut them into large Valentine hearts (or let the children cut out the hearts if they are able to use scissors). Then have the children brush white liquid glue on their hearts and sprinkle them with glitter.

Gluing . . .

CONFETTI

"New Year's collages"

MATERIALS:

Black or dark blue construction paper, various colors of construction paper scraps, tinsel, glue, brushes, hole punch.

PREPARATION:

Use a hole punch to cut little circles from colored construction paper scraps, about a handful for each child.

ACTIVITY:

Have the children brush glue all over their papers. Let them drop strands, or whole handfuls, of tinsel on top of the glue, then sprinkle their papers with little paper circles. When the pictures have dried, hang them on a wall to show off their 3-D effect.

SENT IN BY: Jane Roake, Oswego, IL

CONFETTI

"shake it up"

MATERIALS:

Tagboard, construction paper scraps, glue, shoe box with lid.

PREPARATION:

Cut construction paper scraps into tiny pieces to make confetti and place in a shoebox. Cut holiday shapes such as Easter eggs or Christmas trees out of tagboard.

ACTIVITY:

For each child, make designs with glue on a tagboard shape. Place the shape in the box of confetti and cover with the lid. Give the box to the child and ask him or her to pretend that it's a gift. Have the child shake the box from side to side and try to guess what the gift might be. Then let the child open the box and take out the tagboard shape which will be covered with confetti designs.

VARIATION:

You can follow the same procedure using glitter instead of confetti.

SENT IN BY: Jo Urton, Durant, OK

67

Gluing . . .

WOOD

MATERIALS:

An 8-inch square piece of flat wood for each child, scrap wood, glue, tempera paint and brushes (optional).

PREPARATION:

Cut scrap wood into various shapes such as cubes and triangles, ranging in size from 1 inch to 3 inches.

ACTIVITY:

Let the children glue pieces of scrap wood on their flat wood bases to create towers, houses or other structures. If desired, the finished structures can be painted with tempera, although the natural wood may be more pleasing in the long run.

HINT:

Use these creations as gifts for men on Father's Day, Christmas or other special occasions.

SENT IN BY: Kathy Sizer, Tustin, CA

Gluing . . .

MATERIALS:

Plastic tub lids, glue, assorted dry beans, peas, seeds, cereals, popcorn, macaroni, spaghetti, etc.

ACTIVITY:

Have the children spread a layer of glue inside the tops of their plastic lids. Then let them place dry beans, cereals, seeds and pasta on the glue to create mosaic designs.

SENT IN BY: Kristine Wagoner, Pacific, WA

BEANS

"kitchen collages"

VARIATION:

Before the glue is completely dry, peel the mosaic from the lid. Poke a hole in each mosaic and insert a loop of yarn or string. When the glue dries, it will become transparent. Hang the ornaments in a window to enjoy the see-through effect.

Gluing . . .

BEANS

"toothy smiles"

MATERIALS:
Red construction paper, navy beans, glue, black felt marker.

PREPARATION:
Draw lip shapes on red construction paper with a black felt marker. Draw a horizontal line across the middle of each shape. Cut lip shapes out if children are not yet ready for scissors.

ACTIVITY:
Have children spread glue on the lines in the middle of their lip shapes. Then let them press navy beans on the glue to represent teeth.

HINT:
This activity can be used to reinforce the names of body parts (lips and teeth) and as an art project during Dental Week.

SENT IN BY: Nancy J. Heimark, Grand Forks, ND

VARIATION: From Paula Schneider, Kent, WA
Cut smiling mouth shapes, about 4"x6", from red construction paper. Cut white paper into 8"x½" strips and let the children snip off little pieces to create "teeth." Then let them use glue or liquid starch to stick the teeth onto their smiling mouth shapes.

Gluing . . .

BEANS

"shape ghosts"

MATERIALS:
Black tagboard, black yarn, white lima beans, glue.

PREPARATION:
Cut tagboard into circles, triangles and squares, about 4 or 5 inches across. Punch a hole in the top of each shape. Cut an 18-inch length of yarn for each child.

ACTIVITY:
Explain that the black shapes are ghosts and the beans are ghost eyes. Then let the children glue the bean eyes on their ghosts. Each bean will need only one drop of glue. While you're waiting for the glue to dry, have the children chant the poem below. When the glue is dry, help the children thread their yarn through the holes in their ghosts and tie the shapes around their necks.

POEM:
Sit the children in a circle on the floor. Choose a child and fill in the poem's blanks with his or her name and ghost shape. Continue until everyone has had a turn.

Boo, boo, boo, boo,
(Child's name)'s a ghost to scare you.

To Halloween Town (he/she) comes tonight,

(He/She)'s a (circle/triangle/square) with eyes so white.

Boo, boo, boo, boo,
Boo, boo, boo, boo, BOO!!

SENT IN BY: Faith Adams, Nyssa, OR

"collages"

VARIATION: From Cynthia Holt, Danbury, CT

Fill squeeze bottles with flour and water glue, about the consistency of thick cream, and tint with food coloring. Let children squeeze the glue into vegetable or meat trays and arrange beans on the glue to make collages.

71

Gluing . . .

SEEDS

"pumpkins"

MATERIALS:

Paper plates, pumpkin seeds, glue, orange crayon or felt marker.

PREPARATION:

Use an orange crayon or felt marker to draw pumpkin shapes on the paper plates, one for each child.

ACTIVITY:

Let the children glue pumpkin seeds on their pumpkin shapes. Discussion can center around what's inside of a pumpkin. Or, do the activity the day after you've cleaned out and carved your Halloween Jack-o'-lantern, giving the seeds time to dry.

VARIATION:

Instead of using paper plates, cut pumpkin shapes from orange construction paper and let the children paste on seeds.

SENT IN BY: Marcia Dean, Richland, WA

VARIATION:

Give the children each two paper plates and have them paint their plates on both sides with orange paint. Let them glue seeds on the insides of both plates. Then staple the plates together, leaving a space at the top so children can peek inside to see the seeds.

SIMILAR IDEA SUBMITTED BY: Deborah Balmer, Mesa, AZ

Gluing . . .

SEEDS

"watermelons"

MATERIALS:
Red and green construction paper, watermelon seeds, scissors, glue.

PREPARATION:
For each child, cut a large green circle and a slightly smaller red circle from construction paper.

ACTIVITY:
Have the children glue their red paper circles on top of their green circles. Then let them glue some watermelon seeds on their red circles to make "watermelon slices."

RICE

"shamrocks"

MATERIALS:
Oaktag or heavy white paper, rice, green food coloring, brushes, glue, glue containers, paper towels or pie tins, shamrock pattern.

PREPARATION:
Prepare rice a day ahead of project. Place rice in a small amount of water to which green food coloring has been added. Let it soak until desired shade of green has been reached. Drain off the water and let rice dry on paper towels or in pie tins overnight. Trace and cut out shamrock shapes.

ACTIVITY:
Have the children brush diluted glue on their shamrocks and sprinkle green rice over the glue.

SENT IN BY: Nancy McAndrew, Shavertown, PA

"snowmen"

VARIATION: From Patti Holloway, Deep River, Ontario
Have each child make three circles of glue on a piece of construction paper to resemble a snowman. Pour rice on the glue and shake off excess. The snowmen can be decorated with scraps of fabric.

Gluing . . .

SAND

MATERIALS:

Paper, sand, glitter or rice, white glue, glue brushes, pie tins.

PREPARATION:

Assemble materials and pour glue into pie tins.

"texture pictures"

ACTIVITY:

Invite the children to paint pictures using white glue for paint. Then let them sprinkle pinches of sand, glitter or rice over the glue. Wait a few minutes until the material has had a chance to stick, then shake off the excess.

SENT IN BY: B. Silkunas, Philadelphia, PA

"summer beaches"

VARIATION:

Have the children make "beaches" by brushing glue across the bottom of light blue construction paper and sprinkling sand on the glue. When their papers are dry, let them paste on precut sun and boat shapes to create summer beach scenes.

Gluing . . .

MATERIALS:

Construction paper, salt, dry tempera paint, glue, small brushes, bottles or jars with perforated lids, shallow pan or box lid.

PREPARATION:

Fill shaker bottles with salt and mix with dry tempera paint. Use a different color for each bottle.

ACTIVITY:

Have the children brush designs on their papers with glue. Then let them sprinkle colored salt over the glue and shake off the excess. This will be less messy if you have the children place their papers in a shallow pan or box lid before sprinkling on the salt.

VARIATION:

Give your children pictures cut from old Christmas cards. Have them brush glue over the pictures with Q-Tips or small brushes. Then have them sprinkle plain salt on the glue to create sparkling winter snow scenes.

SALT

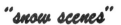

"snow scenes"

"designs"

VARIATION: From Connie Gillilan, Hardy, NE

Cut the construction paper into holiday shapes for the children to "paint" with diluted white glue. Before the glue dries, let the children sprinkle, or shake from a salt shaker, a mixture of powdered tempera and salt on their shapes.

"snow pictures"

VARIATION: From Melode Hurst, Grand Junction, CO

Try "Snow Painting" using dark half-sheets of construction paper and shakers filled with salt, sugar or glitter. Be sure to have plenty of shakers so the children do not have to wait for a turn.

Gluing . . .

SPAGHETTI

"mobiles"

MATERIALS:

Cooked spaghetti, styrofoam meat trays, glue, food coloring, four glue containers.

PREPARATION:

Cook the spaghetti in advance. Noodles will not stick together if oil is added to the water during cooking. Put glue in four containers and add food coloring to make red, blue, green and yellow glue.

ACTIVITY:

Let the children dip spaghetti noodles in colored glue, one noodle at a time, and lay them on their styrofoam trays. Encourage the children to use as many noodles and colors as they wish and to arrange the noodles on their trays in any fashion. When dry, remove the noodles from the trays, tie on pieces of yarn and hang them from the ceiling as mobiles.

HINT:

Small noodle mobiles will dry overnight. Larger ones may take two or three days to dry completely.

SENT IN BY: Nancy J. Heimark, Grand Forks, ND

Gluing . . .

MACARONI

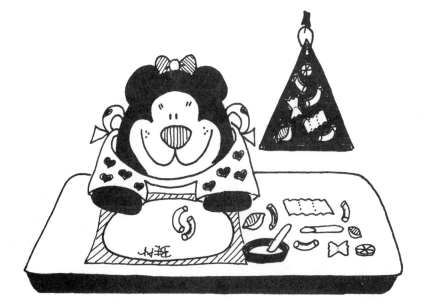

MATERIALS:

Oaktag or light cardboard, various shapes of macaroni, tempera paint and brushes or spray paint, glue, popsicle sticks, newspaper.

PREPARATION:

Cover the table with newspaper. Cut oaktag into desired shapes and sizes. Provide each child with glue and a popsicle stick to use as an applicator.

ACTIVITY:

Have the children cover their shapes with glue and press on the macaroni. When the glue is dry, let the children paint their shapes with brushes or apply spray paint for a special holiday effect. To hang, punch holes in the shapes and tie on loops of yarn.

"holiday collages"

HINTS:

Some suggestions for holiday shapes would be Christmas stars (spray gold), Easter eggs (spray in pastel colors), Valentine hearts (spray red) and Halloween pumpkins (spray orange).

SENT IN BY: Jane Yeiser Woods, Sarasota, FL

Gluing . . .

PUFFED RICE

"pussy willows"

MATERIALS:

Dark blue construction paper, Puffed Rice cereal, glue, brown crayon.

PREPARATION:

Cut blue paper into 5"x7" pieces and draw several straight stems on each piece with brown crayon. (Older children can draw their own stems.) Put bowls of cereal on the table where children can reach them easily.

ACTIVITY:

Let the children glue grains of Puffed Rice up and down both sides of their stems. These spring "pussy willows" almost look real, and the children become very involved in filling up their papers with the little cereal pieces.

HINTS:

If your children are under three, some help will be needed to put the little dots of glue on the stems. Parents enjoy receiving these pussy willow pictures which are fun to do on the first day of spring.

SENT IN BY: Jane M. Spannbauer, So. St. Paul, MN

SIMILAR IDEA SUBMITTED BY:
Nancy McAndrew, Shavertown, PA

MATERIALS:

Colored construction paper, popcorn, glue, crayons.

PREPARATION:

Pop the popcorn.

ACTIVITY:

Have the children glue popcorn on colored construction paper to create winter scenes. Let them add decorations with crayons or paint, if desired.

POPCORN

"snow scenes"

SENT IN BY: Mary Haynes, Lansing, MI

VARIATION: From Connie Gillilan, Hardy, NE

Tint popped popcorn by shaking it with powdered tempera in a brown bag. Then let the children glue tinted popcorn on paper shapes.

"blossoms"

HINT:

Tinted popcorn makes great spring blossoms.

Gluing . . .

MATERIALS:

12"x18" brown construction paper, Cheerios, raisins, red-hots, glue.

PREPARATION:

Cut a gingerbread man shape for each child out of brown construction paper. Assemble materials on the work table.

ACTIVITY:

Let the children glue Cheerios, raisins and red-hots on their gingerbread man shapes to make eyes, noses, mouths, buttons and other decorations.

HINT:

It's fun to eat while you work. Be sure children understand that they should glue first, eat last!

SENT IN BY: Judy Coiner, West Plains, MO

VARIATION:

Use buttons and rickrack instead of food.

SIMILAR IDEA SUBMITTED BY:
Nancy McAndrew, Shavertown, PA

CHEERIOS

"gingerbread people"

Gluing . . .

CORNMEAL

"Halloween shapes"

MATERIALS:

Dry cornmeal or grits, orange or black construction paper, slightly diluted white glue, brushes, shallow box lids, dry tempera paint, empty tennis ball cans with lids.

PREPARATION:

Cut an orange pumpkin shape or a black cat shape out of construction paper for each child. For each color you wish to use, place dry cornmeal or grits in a tennis ball can and shake with a teaspoon of dry tempera paint. Then punch two holes in the lid to make the can into a "shaker."

ACTIVITY:

Have the children place their paper shapes in the shallow box lids and use brushes to paint lines or designs on their paper shapes with glue. Then let them shake the colored cornmeal or grits over their shapes and tip their box lids from side to side until all the glue is covered.

SENT IN BY: Joleen Meier, Marietta, GA

Gluing . . .

TEA LEAVES

MATERIALS:

Brown grocery sacks, used tea bags, brushes, glue, cups, large box lids.

PREPARATION:

For each child, cut a large gingerbread person shape out of a brown paper sack. Cut open the tea bags and put the leaves into small cups.

ACTIVITY:

"gingerbread people"

Have the children brush glue over their gingerbread people shapes and place them in large box lids. Then let the children sprinkle tea leaves on top of the glue and shake off the excess. Pour any leftover tea leaves back into the cups.

VARIATION:

Let your children decorate their gingerbread people with pieces of rickrack and old buttons.

SENT IN BY: Joyce Marshall, Whitby, Ontario

VARIATION:

"teddy bears"

You can also use rinsed coffee grounds to make fuzzy "teddy bears."

Gluing with . . .

TAPE

"collages"

MATERIALS:

Construction paper, large quantities of cheap cellophane tape, smaller quantities of more expensive colored tape in various colors, masking tape, tuna fish cans.

PREPARATION:

Cut tape into various lengths. For each child, make a tape holder by sticking a variety of pieces of tape all around the edges of a tuna fish can. Place them so that they may be pulled off easily. Cut construction paper pieces in half.

ACTIVITY:

Give each child a half sheet of construction paper along with a tape holder. Then let the children make collages by sticking the tape on their papers any way they wish.

HINT:

Give the children separate pieces of tape to hold and play with in their hands. This will help keep them from spending the whole art time playing with the precut tape pieces rather than making collages!

SENT IN BY: Melode Hurst, Grand Junction, CO

Gluing with . . .

MATERIALS:

Pizza wheels or circles cut from cardboard, red tempera paint, liquid starch, yellow cornmeal, construction paper, salt shaker or spice bottle with a perforated lid, large brushes, paint containers.

PREPARATION

Put yellow cornmeal in a shaker container. Cut various food shapes from colored construction paper: brown pepperoni circles, black olives, yellow pineapple wedges, tan mushrooms, etc. Mix red tempera with liquid starch and pour into appropriate containers. Add brushes.

ACTIVITY:

Have the children brush red paint "tomato sauce" generously over their cardboard circles. Then let them arrange their paper shape "foods" on top of the wet paint and sprinkle cornmeal "cheese" all over their circles to make "pizzas."

SENT IN BY: Ruth Engle, Kirkland, WA

"pizzas"

PAINT

"color murals"

MATERIALS:

Butcher paper, old magazines, paintbrushes, paint.

PREPARATION:

Attach a large sheet of butcher paper to a wall.

ACTIVITY:

Choose a color you want to work on, such as red. Let the children look through magazines and tear out pictures of red items. Then have them brush red paint on the butcher paper and press the magazine pictures on the wet paint to create a group "red mural." Repeat the activity on other days with different colors.

Gluing with . . .

CONTACT PAPER

MATERIALS:

Contact paper, various collage materials such as colored tissue paper, yarn, paper scraps, wrapping paper and noodles.

PREPARATION:

"heart collages"

Cut contact paper into shapes at least 6 inches in diameter. Remove the backing from each shape, perhaps leaving a border around the edges. Cut tissue paper, paper scraps and wrapping paper into squares or other small shapes.

ACTIVITY:

Let the children make collages by pressing colored paper pieces, yarn and noodles on the backs of their contact paper shapes. The sticky surface eliminates the need for glue.

SENT IN BY: B. Steinbock & R. Oxman, Portland, OR

VARIATION: From Marna Reigstad, Simi Valley, CA

"holiday shapes"

For each child, cut a shape such as a Christmas tree, stocking, Easter egg, flower or kite out of the center of a piece of construction paper. Place a piece of contact paper, with backing removed, over the opening and turn the paper over. Invite the children to press small multicolored pieces of construction paper on the adhesive paper. Let them tear the construction paper themselves or precut the paper into tiny pieces. For a Christmas tree, you may want to have the children add a star sticker at the top. You may also want to cover the finished pictures with clear plastic wrap, since uncovered areas of the adhesive paper will be sticky.

Gluing with . . .

MATERIALS:

Old, unworkable playdough (or fresh), styrofoam trays, beans, straws, colored toothpicks, pipe cleaners and other small objects, egg cartons or TV dinner trays, newspaper.

PREPARATION:

Assemble styrofoam trays and small objects to stick in playdough. Put objects in egg cartons or TV dinner trays to use as display containers. Cover table with newspaper. If using fresh playdough, make recipe:

> 5 cups flour
> 1 cup salt
> ½ cup oil
> 2 cups water
> food coloring

Mix ingredients together well.

"object collages"

ACTIVITY:

Give each child a sytrofoam tray with a clump of playdough on it. Then let the children use the playdough as a base for sticking in beans, straws, toothpicks and other small items so that they stand upright. The children can share display containers, or each child can have his or her own.

SENT IN BY: Cynthia Holt, Danbury, CT

PEANUT BUTTER

MATERIALS:

Crackers of assorted shapes and sizes, peanut butter, plastic knives, small paper plates, newspaper.

PREPARATION:

Cover table with newspaper. Put peanut butter on paper plates. Provide each child with a knife.

ACTIVITY:

Let the children create cracker sculptures, using the peanut butter as an adhesive. They can save their sculptures or eat them for snacks.

HINT:

You can also use animal crackers.

SENT IN BY: Jane Yeiser Woods, Sarasota, FL

OIL

MATERIALS:
Waxed paper, red tissue paper, salad oil, cotton balls, pie tins.

PREPARATION:
Cut a large heart shape out of waxed paper for each child. Pour salad oil into pie tins.

"tissue paper hearts"

ACTIVITY:
Have the children dip cotton balls into the oil and brush it over their hearts. Then have them tear red tissue paper into little pieces and press them all over their hearts until they are completely covered. The oil will help the tissue paper stick to the hearts while making the red color translucent.

VARIATION:
Cut other holiday shapes, such as shamrocks or pumpkins, out of waxed paper and let the children use green or orange tissue paper to decorate them.

PRINTING

Printing with . . .

COOKIE CUTTERS

"shape pictures"

"holiday prints"

MATERIALS:

Construction paper, cookie cutters, paint, shallow pans, paint shirts, soapy water, paper towels.

PREPARATION:

Pour paint into shallow pans. Assemble cookie cutters and have soapy water and paper towels handy for cleanup.

ACTIVITY:

Let each child choose a cookie cutter, dip it in paint and then press it on paper to create a print.

VARIATION:

Provide red, yellow and blue paint and let the children make prints with all three colors. Point out the secondary colors when the primary colors blend together on their papers. When the paint is dry, let the children color in details with crayons.

HINT:

The best cookie cutters are the ones with little handles.

SENT IN BY: Mary Jane Downs, Pittsburgh, PA

SIMILAR IDEAS SUBMITTED BY:
Ruth Engle, Kirkland, WA
B. Silkunas, Philadelphia, PA

Printing with . . .

WHEELS

"tracks"

MATERIALS:

Construction paper, small plastic cars, various colors of tempera paint, shallow containers, paint smocks.

PREPARATION:

Pour paint in shallow containers. Cover the table and protect the children's clothing with paint smocks.

ACTIVITY:

Let the children dip the wheels of the small cars in paint and "drive" them back and forth across their papers to make tracks. This is popular even with "non-artists" and is usually accompanied by lots of sound effects. A good name for this activity would be "Zoom-Zoom Painting!"

SENT IN BY: Barbara H. Jackson, Denton, TX

VARIATION: From Barbara Robinson, Glendale, AZ

Tape a long sheet of butcher paper on a table top or on the floor. Have the children select small vehicles, dip the wheels lightly into paint and then "drive" the vehicles over the butcher paper. Hang the butcher paper track mural on a wall and discuss with the children which kind of vehicle made each type of track.

SIMILAR IDEA SUBMITTED BY: Janet Harles, Moorhead, MN

Printing with . . .

CIRCLE SHAPES

MATERIALS:

Construction paper, tempera paint, objects that can be used to make circle shapes such as thread spools, plastic drinking glasses, corks, round cookie cutters, etc.

PREPARATION:

Cut a large circle out of construction paper for each child.

ACTIVITY:

Let the children use spools, plastic glasses and different sizes of other round objects to print with tempera paint on their large paper circles. This is a good activity to use when you are working on the circle shape.

SENT IN BY: Joleen Meier, Marietta, GA

SIMILAR IDEA SUBMITTED BY: B. Silkunas, Philadelphia, PA

SCRAP MATERIALS

"shape designs"

MATERIALS:

Construction paper, corks, small wood scraps, styrofoam pieces, 35 mm film cases, four colors of paint, shallow containers, bucket of water, paper towels, smocks, newspaper.

PREPARATION:

Ask local businesses to donate scrap materials: restaurants/bars — wine corks; furniture factory — wood scraps; stores — styrofoam packing pieces; photography studio — 35 mm film cases. Cover the table with newspaper. Pour paint into shallow containers, ½-inch deep, and put some scrap materials into another container on the table. Place bucket of water and paper towels nearby for easy cleanup.

ACTIVITY:

Have four children at a time put on smocks and roll up their sleeves. Then let them dip the scrap materials in paint and press them on their papers to make prints. The scrap materials can be disposed of when paint-covered, making cleanup a breeze.

SENT IN BY Suzanne L. Friedrich, Pittsburgh, PA

Printing with . . .

STYROFOAM

MATERIALS:

Construction paper, styrofoam trays, poster paint, liquid soap, paintbrushes.

PREPARATION:

Add a drop of liquid soap to the paint.

"design prints"

ACTIVITY:

Turn the styrofoam trays upside down. Have the children use the ends of their paintbrush handles to etch designs on the backs of their trays. Then have them brush paint over their designs and press paper on top of the paint to make prints. Help them to carefully remove their papers to see the designs they created.

SENT IN BY: Ann Fair, Uniontown, MD

SIMILAR IDEA SUBMITTED BY: Ruth Engle, Kirkland, WA

YARN

"yarn prints"

MATERIALS:

Construction paper, trays with smooth surfaces, thick and thin yarn, poster paint, liquid soap, paintbrushes.

PREPARATION:

Add a drop of liquid soap to the paint.

ACTIVITY:

Have the children brush paint on their tray surfaces and drop yarn on the paint in various patterns. Then let them press paper on top of the paint to make prints. Help them carefully remove their papers to see the designs they created.

SENT IN BY: Ann Fair, Uniontown, MD

Printing with . . .

CORRUGATED CARDBOARD

MATERIALS:

Construction paper, corrugated cardboard, masking tape, brightly colored tempera paint, paper towels, foil pans or meat trays.

PREPARATION:

Cut corrugated cardboard into suitable lengths and roll tightly. Secure with masking tape. Make paint pads by placing folded paper towels in the bottom of foil pans or meat trays. Pour paint on top of the pads.

"flowers"

ACTIVITY:

Let the children dip the ends of the corrugated cardboard rolls into paint and then press them on their papers to make prints.

SENT IN BY: Jacqueline McCracken, Ladysmith, British Columbia

"wreaths"

VARIATION:

Vary the color of paint according to seasons or holidays. Use different colors of paint to make spring flowers. Use green paint to make bushes in a garden or Christmas wreaths.

LEAVES

MATERIALS:

Construction paper, assorted leaves, tempera paint, brushes.

ACTIVITY:

"leaf prints"

Let each child select a leaf and brush paint over the back side. Then have the child press the leaf on construction paper to make a print.

SENT IN BY: Marlene Filsinger, Snyder, NY

Printing with . . .

CASTERS

MATERIALS:

Construction paper, round Spike Caster Cups (used under furniture to protect carpets), paint, sponges, paint containers.

"dot prints"

PREPARATION:

Put sponges in containers and pour on different colors of paint to make paint pads.

ACTIVITY:

Have the children press the casters on the sponge paint pads, then stamp them on their papers in any designs they wish. Encourage them to try different colors until they are satisfied with their designs.

SENT IN BY: Sr. Mary Bezold, Melbourne, KY

JARS

MATERIALS:

Construction paper, baby food jars, paint, small trays.

PREPARATION:

Pour enough paint in each tray to just cover the bottom.

"circle prints"

ACTIVITY:

Let the children dip the tops of their baby food jars in the paint, then press them on their papers to make prints.

SENT IN BY: Cathryn Abraham, St. Charles, IL

Printing with . . .

VEGETABLES

MATERIALS:

Construction paper, vegetables such as broccoli, cauliflower, onions, mushrooms and potatoes, knife, tempera paint, styrofoam trays, thin sponges or paper towels.

PREPARATION:

Cut the vegetables in cross sections to make flat printing surfaces and interesting shapes. Put sponges or folded paper towels in trays and pour on small amounts of paint.

ACTIVITY:

Have the children dip the vegetables in paint and then make prints of them on their papers.

SENT IN BY: Ruth Engle, Kirkland, WA

"pizzas"

VARIATION:

A fun variation of vegetable printing is making pizza prints. Give each child a large circle of yellow paper and let him or her use cut vegetables to make prints on the paper to represent items on a pizza. Carrots are good for making prints that resemble pepperoni slices.

"lemons"

"oranges"

VARIATION:

Children can make beautiful prints using lemons and oranges. Cut the fruit in half and let it dry out a bit. Then have the children dip the fruit into paint and make prints on their papers. One or several colors could be used.

VARIATION: From Marion Ekberg, Gig Harbor, WA

Have the children make vegetable prints on paper plates.

"holiday prints"

VARIATION:

Cut holiday shapes, such as Christmas trees or Easter eggs, out of vegetables and let the children use them to stamp designs on tissue paper or newsprint. The paper can then be used as holiday giftwrap.

Printing with . . .

POTATOES

MATERIALS:
Brown paper bags, potatoes, knife, paint.

PREPARATION:
Cut brown paper bags into large potato shapes. Cut potatoes into various shaped pieces.

ACTIVITY:
Let the children dip small pieces of potato into paint and then use them like stamps to make designs on their paper potato shapes.

"shape prints"

HINT:
Leftover potato pieces can be saved and cooked for snacks.

SENT IN BY: Joyce Marshall, Whitby, Ontario

APPLES

"apple art"

MATERIALS:
Construction paper, apples, red, yellow and green liquid tempera paint, meat trays, paper towels, knife.

PREPARATION:
Cut apples in half crosswise. Wipe off the cut surfaces and let apples dry for about an hour. Place folded paper towels in meat trays and pour on liquid tempera to make paint pads.

ACTIVITY:
Have the children dip the cut surfaces of the apples into paint and then press them on their papers to make apple prints.

Printing with . . .

CORNCOBS

"designs"

"flowers"

MATERIALS:
Construction paper, corncobs, meat trays, paper towels, paint.

PREPARATION:
Save the cobs from a corn-on-the-cob meal and let them dry for several days. Place folded paper towels in meat trays and pour on liquid tempera to make paint pads.

ACTIVITY:
Let the children roll corncobs on their paint pads and then roll the cobs across their papers to make corncob prints.

SENT IN BY: Joyce Warden, Philadelphia, PA

VARIATION:
Use a large knife or handsaw to cut the corncobs in half. Then let the children dip the cutoff ends in paint and press them on their papers to make corncob "flowers." Yellow, pink or orange paint looks nice on light blue or green construction paper.

Printing with . . .

BERRY BASKETS

MATERIALS:

Construction paper, plastic berry baskets, tempera paint, shallow paint containers, smocks.

"basket weaves"

PREPARATION:

Assemble supplies. Cover the art table and have children put on smocks. Pour paint into paint containers.

ACTIVITY:

Have the children dip the bottoms of plastic berry trays in paint, then press them on construction paper to make designs.

HINT:

If paint colors are selected by the teacher, perhaps the children could choose their own paper colors to give variety to the finished products.

SENT IN BY: Barbara H. Jackson, Denton, TX

Printing with . . .

STAMPS

"holiday prints"

MATERIALS:

Plain paper, plain paper bags or other kinds of paper, Scholl's Insoles, 2-inch square wooden blocks, commercial ink pads.

PREPARATION:

Using scissors, cut shapes such as hearts, stars or Christmas trees from Scholl's Insoles and glue them on the wooden blocks to make stamps.

ACTIVITY:

Have the children use the stamps and ink pads to make designs all over their papers or paper bags. The finished products can be used for wrapping gifts or for making greeting cards.

HINTS:

Even the smallest child has success if commercial ink pads are used. They seem to work better than paint pads made with paper towels and tempera. And even the busiest teacher has success using Scholl's Insoles, which are easier to cut into shapes than the traditional potatoes or linoleum blocks.

SENT IN BY: Kathy Sizer, Tustin, CA

VARIATION: From Ruth Engle, Kirkland, WA

Use a utility or craft knife to carve shapes in gum erasers. Then let the children use the erasers as stamps to make prints on their papers.

Printing with . . .

BUBBLES

MATERIALS:

Paper, tempera paint, liquid detergent, water, quart container, shallow aluminum pan, straws (*not* flexible straws).

PREPARATION:

The night before, mix ⅓ cup tempera paint with ⅓ cup liquid detergent in a quart container. Add water and stir. Let the contents sit overnight. (If you wish to use several colors, make a separate solution for each one.)

ACTIVITY:

Pour the paint mixture into a shallow pan. Demonstrate how to make bubbles by blowing through a straw. Then let two or three children at a time blow bubbles in the paint mixture. While they are enjoying this experience, place paper over the bubbles as they reach the top of the pan. The paint bubbles will pop on the paper, leaving beautiful designs.

HINT:

Try various kinds of paper for different results.

SENT IN BY: Diane Torgan, Englewood, CO

VARIATION: From Jenifer Contaya, Arlington, TX

Use a good brand of liquid soap such as Ivory. Pour a layer of soap into a shallow pan and add water. Let one child at a time blow large bubbles in the water with a straw. When the bubbles are quite high, add several drops of food coloring. Let the child pick the color. Then have the child slowly lower a paper plate onto the bubbles, being careful not to let it touch the water.

HINTS: From Jenifer Contaya, Arlington, TX

If bubbles pop too quickly, add a few tablespoons of sugar to the water. Poke holes near the tops of the straws to prevent children from sucking up the soapy water.

"bubble pictures"

Printing with . . .

SPONGES

"seasonal shapes"

MATERIALS:
Paper, small sponge pieces, paint, meat trays, paper towels.

PREPARATION:
Make stamp pads by placing folded paper towels in meat trays and pouring small amounts of paint on the towels.

ACTIVITY:
Let the children dip the sponge pieces into the paint and dab them on their papers to make prints.

HINT:
Handles can be made by clipping clothespins to the small sponge pieces.

FROM: Catherine Arsenault, Tacoma, WA

VARIATION: From B. Silkunas, Philadelphia, PA

Make stencils by cutting shapes such as triangle trees, large hearts or pumpkins out of the middle of sheets of cardboard. Tape the stencils to windows and let the children sponge paint over them.

VARIATION: From Barbara H. Jackson, Denton, TX

Let the children paint with sponges that are attached to handles (used for cleaning glasses and bottles). Have the children dip the sponges in paint and then dab them on their papers. Provide two or three different colors, with a sponge for each color, to add variety.

VARIATION: From Marlene Filsinger, Snyder, NY

Cut large pumpkin shapes out of orange paper and cut sponges into triangle shapes. Then let the children dip the sponge triangles into black paint and use them to create pumpkin faces or designs on their papers.

"pumpkin faces"

SIMILAR IDEA SUBMITTED BY: Janet Harles, Moorhead, MN

Printing with . . .

SPONGES

"hearts"

"Christmas trees"

VARIATION: From Sr. Mary Bezold, Melbourne, KY
Cut sponge pieces into seasonal shapes such as hearts for Valentine's Day or trees for Christmas.

HINT: From Sr. Mary Bezold, Melbourne, KY
Lauri rubber puzzle shapes can be used in place of sponge shapes for printing.

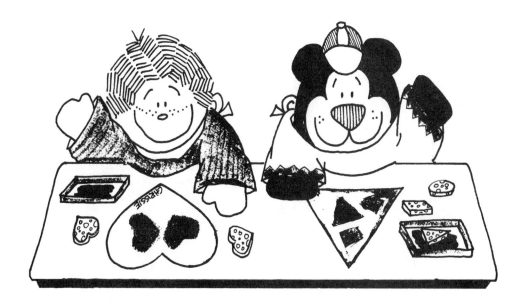

SPONGES

"cookie cutter shapes"

MATERIALS:
Tissue paper, cookie cutters, sponges, felt marker, tempera paint, pie tins.

PREPARATION:
To make each shape to use for printing, set a cookie cutter on a sponge and trace around it with a felt marker. Then cut out the shape with scissors. Pour paint into pie tins and lay tissue paper out on a table top.

ACTIVITY:
Have the children dip the sponge shapes into the paint and then press them on the tissue paper to create designs.

SENT IN BY: Barbara Robinson, Glendale, AZ

Printing with . . .

FINGERS

"blossoms"

"apples & cherries"

"snowflakes"

MATERIALS:

Paper, tempera paint, small styrofoam trays.

PREPARATION:

Pour small amounts of paint into styrofoam trays. Place sheets of paper on the table.

ACTIVITY:

Have the children dip their fingers into the paint and then press them on their papers to make prints. Encourage the children to experiment by using one finger at a time, many fingers at once, fingers held together and fingers spread apart.

VARIATION:

Draw a bare tree on each paper and let the children make fingerprints on the branches to represent blossoms. Use pink paint for cherry blossoms and white paint for apple blossoms.

VARIATION:

Have the children make red fingerprints on green construction paper trees to represent apples or cherries.

VARIATION:

Make winter scenes by gluing snowmen or evergreen tree shapes on dark blue paper. Then have the children make white fingerprints all over their pictures to represent snowflakes.

SENT IN BY: Ruth Engle, Kirkland, WA

SIMILAR IDEA SUBMITTED BY: Sally Horton, Waukegan, IL

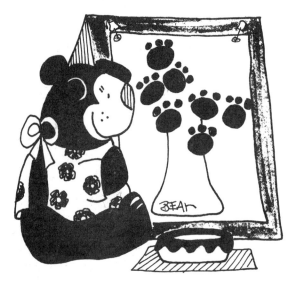

Printing with . . .

VARIATION: From Agnes Kirchgasler, Salt Lake City, UT

Have the children press their fingers on red and black stamp pads and make fingerprints on their papers. Then use a fine-lined black marker to make the children's prints into things such as fish, mice, birds, people and flowers.

"fish"

"birds"

VARIATION: From Mary Haynes, Lansing, MI

Let the children decorate tree shapes by making fingerprint "leaves." Use green paint for spring and red and yellow paint for autumn.

"leaves"

VARIATION: From Lena Goehring, Columbus, PA

Glue five bottlecaps in a semicircle on a piece of heavy cardboard. Put five different colors of paint into the caps. Let each child dip the fingers of one hand into the five caps all at once and then make prints of his or her colored fingertips on paper. Then let the child draw lines down from the fingerprints, making them into five colored balloons or lollipops.

VARIATION: From Lena Goehring, Columbus, PA

Have the child make five fingerprints as described in the activity above. Next, let him or her tear a picture of a person from a magazine and paste it next to the prints. Then draw lines from the fingerprints to the hand of the person, making it look as if the person is holding a bunch of balloons.

VARIATION: From Ann Fair, Uniontown, MD

Use a brown felt marker to draw branches on pastel contruction paper. Then let the children dip their index fingers into gray paint and make prints along the branches to create pussy willows, or into yellow paint to create forsythia.

SIMILAR IDEAS SUBMITTED BY:
Sally Horton, Waukegan, IL
B. Silkunas, Philadelphia, PA
Jan Yeiser Woods, Sarasota, FL

"pussy willows"

Printing with . . .

FEET

MATERIALS:

Long roll of butcher paper, two or three washtubs, liquid tempera paint, towels, warm soapy water.

PREPARATION:

Mix tempera paint thicker than usual. Cover the bottoms of one or two tubs with paint. Fill a third tub with warm soapy water. Spread out a 6-foot piece of paper and place the paint at one end and the water at the other.

ACTIVITY:

After removing shoes and socks, let one child at a time step into his or her choice of paint and walk the entire length of the paper, leaving footprints. Then have the child wash his or her feet in the tub of water.

SENT IN BY: Jane M. Spannbauer, So. St. Paul, MN

"footprints"

VARIATION: From Cindy Dingwall, Palatine, IL

Let the children print with their feet outdoors on a sunny day. Anchor the paper with rocks and paint the bottoms of the children's feet before they walk across the paper.

HINT: From Cindy Dingwall, Palatine, IL

It helps to have one adult painting feet, one holding the child's hand as he or she walks across the paper and one to wash feet at the end. Have another adult stay with the group while each child is taking his or her "paint walk."

VARIATION: From Cynthia Holt, Danbury, CT

Place an old piece of carpet in the bottom of the tub and soak it with paint. Put a chair at one end of the paper for the children to sit on while they place their feet on the paint-soaked carpet.

VARIATION: From Cynthia Holt, Danbury, CT

Do this activity with paint and brushes, letting the children take turns painting the bottoms of each other's feet.

Printing with . . .

MATERIALS:

Fingerpaint paper, fingerpaint, a 4- to 6-foot length of newsprint, newspapers, masking tape, tub of soapy water, paper towels.

PREPARATION:

Tape two sheets of newspaper on the floor, side by side. Tape a piece of fingerpaint paper on each sheet of newspaper and write a child's name on each piece. Set a chair at each place. Lay newsprint out in front of painting area and secure with tape. Place soapy water and towels in cleanup area.

ACTIVITY:

Let two children at a time sit in the chairs and "fingerpaint" with their feet on the fingerpaint paper. Then have them walk across the newsprint to the cleanup area. Write each child's name near one or two of his or her footprints on the newsprint. After displaying the newsprint mural, individual footprints can be cut out and sent home with the children.

HINTS:

This works well when you have an aide help with the washing of feet while you supervise the painting. Rolling pant legs up over the children's knees will help keep pants free of paint.

SENT IN BY: Vicki Shannon, Napton, MO

VARIATION: From Betty Ruth Baker, Waco, TX

Let each child create "butterfly wings" by making two yellow footprints side by side. Turn the paper so that the toes point upward, then draw a body, head and antennas between the two prints.

"butterflies"

VARIATION: From Betty Ruth Baker, Waco, TX

Have each child make a yellow footprint. Turn the paper so that the toes point down. Then draw an eye and a bill on the heel to make the print into a "chick."

"chicks"

VARIATION: From Jenifer Contaya, Arlington, TX

Have the children make white footprints on black paper to create "ghosts." When the paint is dry, let them draw faces on their ghosts with black felt markers.

"ghosts"

HANDS

MATERIALS

Paper, large ink pad or tempera paint and a sheet of plastic.

PREPARATION:

Cut paper in desired shapes and sizes. Prepare the ink pad or mix tempera to the consistency of cream and spread it on a sheet of plastic.

"Christmas trees"

ACTIVITY:

Let the children place their hands in paint and then decorate their papers with handprints. An upside-down hand makes a nice "Christmas tree," and two overlapped hands make a pretty "heart" that parents will enjoy keeping.

"butterflies"

SENT IN BY: Ann Herold-Short, Rushville, IN

VARIATION: From Betty Ruth Baker, Waco, TX

Pour bright colored tempera paint into a cake pan. Have each child make a "butterfly" by placing both hands in paint and printing on construction paper or tagboard with fingers together and thumbs touching. When papers are dry, add antennas with a black marker or glue on black pipe cleaners.

VARIATION: From Jenifer Contaya, Arlington, TX

Let the children use their hands to make turkey prints. Paint the palm of each child's hand brown. On the fingers, paint a strip of orange, a strip of yellow, then another strip of orange. Paint the thumb red. Then have the child place the hand on paper and move his or her fingers back and forth. The palm becomes the turkey's body, the fingers its feathers and the thumb its head. The child may draw on facial features and legs when the turkey print dries. Note that older children may enjoy painting their own hands.

"turkeys"

"hearts"

106

Prints of . . .

MATERIALS:

Butcher paper, liquid starch and dry tempera or prepared fingerpaint, low table with a smooth, washable surface, paint smocks.

PREPARATION:

Cut paper into large shapes such as leaves for fall, trees for Christmas, hearts for Valentine's Day, eggs for Easter, butterflies for spring or geometric shapes. Pour small pools of liquid starch on the table top and sprinkle with dry tempera, or use prepared fingerpaint.

"hearts"

ACTIVITY:

Let each child fingerpaint directly on the table in any desired fashion. When the "picture" is done to the child's satisfaction, press a precut paper shape over the paint to make a print.

HINTS:

More starch or drops of water may be added if drying occurs. Add more fingerpaint as needed.

SENT IN BY: Ruth Engle, Kirkland, WA

VARIATION: From Mary Jane Downs, Pittsburgh, PA

Use large cafeteria trays on which to spread the fingerpaint. The children may then leave and return to the activity often. Use combs to make swirls and line designs. Try adding rice or sand to the paint for texture.

"holiday cutouts"

107

PAINT BLOTS

MATERIALS:

Manila drawing paper, assorted tempera paints, paint containers, eye-droppers, newspaper, paint smocks.

PREPARATION:

Spread newspaper over table. Set out tempera paints in individual containers with an eyedropper in each. Write children's names on papers.

ACTIVITY:

Let two children at a time use eyedroppers to drop paint onto their papers and help them fold their papers in half. Then let the children press and smooth their papers and unfold them. This activity is good for developing fine motor skills.

VARIATION:

No matter where the paint is dropped onto the paper, it always resembles a butterfly. If desired, let the children glue on precut butterfly bodies when their papers have dried.

HINTS:

Tupperware cups in 4- or 6-ounce sizes make excellent paint containers and have lids which can be resealed to keep paint from drying out. Disposable plastic eyedroppers are safest and make cleanup easy.

SENT IN BY: Vicki Shannon, Napton, MO

"butterflies"

VARIATION: From Barbara H. Jackson, Denton, TX

Cut out paper butterfly shapes and fold them in half for the children to use when blot painting. Use baby food jars as paint containers and make a holder for them by cutting circles in the lid of an egg carton.

VARIATION: From Carole Hardy, Pittsburgh, PA

Instead of tempera paint, use food coloring. After each child makes a design by folding and pressing paper, discuss what it looks like. Then cut out the design in the desired shape and mount it on a piece of construction paper.

SIMILAR IDEA SUBMITTED BY:
Barbara Dunn, Hollidaysburg, PA

MODELING

Modeling with . . .

CLOUD DOUGH

MATERIALS:

Flour, vegetable oil, water, powdered tempera paint, large bowl.

PREPARATION:

Mix 6 cups flour with desired amount of powdered tempera paint in a large bowl. Add 1½ cups oil and 1 cup water and knead well. If necessary, add more water, in small amounts, until the dough is soft and fluffy. More flour can be added if the dough becomes too sticky.

ACTIVITY:

Playing with this soft, elastic dough is like playing with clouds — great for little fingers! Let the children experiment with patting, squeezing and pulling the dough into various shapes.

HINTS:

Since the dough contains oil, you may wish to have the children wear smocks. Store dough in a covered container in the refrigerator.

SENT IN BY: Gayle Bittinger, Everett, WA

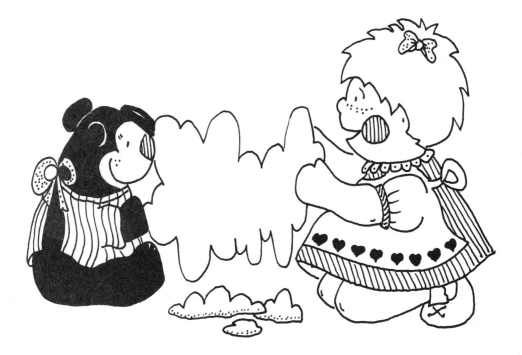

Modeling with . . .

PLASTER

"bag sculptures"

MATERIALS:

Quick-setting plaster, a small plastic bag for each child, dry tempera or liquid tempera and brushes.

PREPARATION:

Pour quick-setting plaster into each child's bag. If desired, mix with dry tempera. Next, add sufficient water to form soft dough.

ACTIVITY:

Have each child gently squeeze his or her plastic bag to mix the water and plaster. When the plaster feels warm, it will begin to set. Have the children hold their bags in desired shapes until the plaster hardens. If dry tempera was not mixed with the plaster, let the children paint their forms with liquid tempera

SENT IN BY: Jan Goldstein, Indianapolis, IN

Modeling with . . .

SHREDDED WHEAT

"wreath ornaments"

MATERIALS:

Large Shredded Wheat biscuits, green food coloring, white glue, small margarine lids, small red beads or red-hots, red ribbon or yarn, bowls.

PREPARATION:

For each child, crumble one large Shredded Wheat biscuit into a bowl. Mix 5 drops of green food coloring with ¼ cup white glue and add to the cereal.

ACTIVITY:

Have each child mix the green glue and Shredded Wheat together until the cereal is completely coated. Help the child pile the mixture on top of a small margarine lid and shape it into a wreath. Then let the child decorate the wreath by pressing red beads or red-hots into the green mixture. Leave the wreath on the lid to dry. While it's still partially wet, make a hole in the top with a pencil point and use a needle to insert ribbon or yarn for hanging. The wreath will dry in about 24 hours. Peel it off the lid, and it's ready for the tree!

SENT IN BY: Jenifer Contaya, Arlington, TX

WET SAND

"castles"

"cakes"

MATERIALS:

Plastic dishpan filled with 3 or 4 inches of sand, sturdy cups and containers of various sizes, water.

ACTIVITY:

Add a little water to the pan of sand and demonstrate how to mold a structure. Then invite each child to create a village, a group of cakes or whatever he or she chooses.

SENT IN BY: B. Silkunas, Philadelphia, PA

Modeling with . . .

BREAD DOUGH

MATERIALS:

A loaf of frozen bread dough for each 8 to 10 children, cookie sheets, oil, one egg, small bowl, salt or a sugar and cinnamon mixture, clean brush, pan, oven.

PREPARATION:

The night before, thaw frozen bread dough in refrigerator. Shape dough into small balls, two or three per child. Preheat oven to 350 degrees. Lightly grease cookie sheets. Crack egg and separate out egg white. Beat egg white with 1 or 2 teaspoons of water in a small bowl. Place a pan of boiling water in the oven to help with the texture of the baked bread.

ACTIVITY:

Let the children play with the bread dough like playdough. They can hammer it, roll it, cut it, etc. Have them form the dough into pretzel shapes, letters or natural "lumps," then place the shapes on cookie sheets. Let the children help brush egg white on their dough shapes and sprinkle on salt or a sugar and cinnamon mixture. Put the dough shapes in the oven and bake for 20 minutes.

SENT IN BY: Melode Hurst, Grand Junction, CO

"pretzels"

"letters"

"shapes"

Modeling with . . .

PLAY DOUGH

"play dinners"

MATERIALS:

Large bowl, measuring cups and spoons, mixing spoons, cookie cutters, kitchen gadgets, flour, salt, water, vegetable oil, food coloring.

PREPARATION:

Let children help make three or four batches of different colored playdough. For each batch, mix together 1 cup flour, ½ cup salt, 3 to 4 tablespoons water, 1 tablespoon vegetable oil and food coloring.

ACTIVITY:

Ask the children what they would like to make for dinner. Green peas? Yellow beans? Macaroni? Strawberries? Encourage healthy foods. Then let the children use cookie cutters, kitchen gadgets or their hands to make "pretend" foods with the playdough.

SENT IN BY: Mrs. David Zucker, Reno, NV

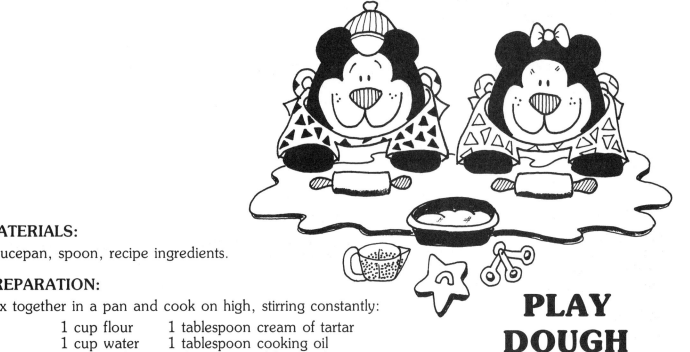

PLAY DOUGH

"relaxing fun"

MATERIALS:

Saucepan, spoon, recipe ingredients.

PREPARATION:

Mix together in a pan and cook on high, stirring constantly:

1 cup flour	1 tablespoon cream of tartar
1 cup water	1 tablespoon cooking oil
½ cup salt	A few drops of food coloring

Remove from heat when playdough reaches correct consistency. Cool.

ACTIVITY:

Working with playdough relaxes children in new situations. Let them work with this mixture on the first day of school.

HINTS:

This playdough will last a long time if stored in a plastic bag or refrigerator bowl. The recipe doesn't work well if doubled.

SENT IN BY: Judy Coiner, West Plains, MO

Modeling with . . .

PEANUT BUTTER PLAYDOUGH

MATERIALS:

Peanut butter, non-fat dry milk, kitchen utensils.

PREPARATION:

Mix equal amounts of peanut butter and non-fat dry milk together to the consistency of playdough, adding more peanut butter or dry milk as needed. Make sure table surface and playing utensils are clean, because the children will eat this mixture.

"playtime edibles"

ACTIVITY:

Invite the children to feel, smell, taste and create with this different kind of playdough.

HINT:

This is a particularly good activity for children who still explore things by putting them in their mouths. It stimulates all the senses, especially smelling and tasting!

SENT IN BY: Rosemary Spatafora, Pleasant Ridge, MI

PLAY DOUGH

"ornaments"

MATERIALS:

Salt, flour, water, dry tempera paint, cookie cutters in holiday or other shapes, pencil with eraser, yarn, newspaper, glue and glitter (optional).

PREPARATION:

Make playdough by mixing together 1 cup salt, 1 cup flour and ½ cup water. If necessary, add more flour to make doughy consistency. Add dry tempera and mix in well.

ACTIVITY:

Let the children play with the playdough. Next, have them use their hands to roll the dough and flatten it so it is about ½ inch thick. You may need to help with this. Then let the children use cookie cutters to cut ornaments out of the playdough. Place the ornaments on newspaper and poke holes in the tops with the eraser end of a pencil. Let the ornaments dry for 24 hours, turn them over, then let them dry for another 24 hours. Allow more drying time as needed. If desired, the children may add small amounts of glitter to their ornaments. Just apply white glue, sprinkle on glitter and shake off the excess. Tie yarn through the holes for hanging ornaments.

HINT:

These make nice holiday gifts for parents.

SENT IN BY: Cindy Dingwall, Palatine, IL

MARKING

CRAYONS

MATERIALS:

Aluminum foil, waxed paper, crayons, electric warming tray.

PREPARATION:

Put the warming tray on a table. Make sure the plug will not be in the way. Place a layer of foil over the heating surface before turning on the warming tray. The foil will protect the warming tray from crayon marks and keep the coloring even. Place a piece of waxed paper over the foil. You will know the tray is warm enough when the waxed paper begins to adhere to the foil.

"stained glass designs"

ACTIVITY:

Let one child at a time select crayons and color on the waxed paper. The crayons will melt as the child colors, blending together to make designs.

HINT:

Show the children how to hold the crayons so that their fingers do not touch the surface of the warming tray.

SENT IN BY: Annette Gagliardi, Minneapolis, MN

Marking with . . .

CRAYONS

"prints"

MATERIALS:
Cookie sheet, hot plate, aluminum foil, drawing paper, crayons, roller, paper towels.

PREPARATION:
Cover cookie sheet with aluminum foil. Turn the hot plate on low and place the cookie sheet on top of it.

ACTIVITY:
Let one child at a time draw with a crayon on the aluminum foil. As he or she draws, the colors will melt. Next, place a piece of drawing paper over the foil and roll with a roller to transfer the crayon designs onto the paper. Then lift the paper and let it dry. Clean off the foil with a paper towel before the next child begins.

HINT:
Always do this activity with just one child at a time.

SENT IN BY: Mary Haynes, Lansing, MI

★ **WARNING:**

Activities that involve using an electric warming tray or a hot plate require adult supervision at all times.

119

CRAYONS

"snakes"

MATERIALS:

Paper plates, crayons.

ACTIVITY:

Have the children use crayons to color designs on both sides of their paper plates. Then cut each plate around and around in a spiral so that when you are finished, it resembles a snake. Draw an eye on one end. Then hang the finished products. If your children are older, they may be able to cut the paper plates themselves.

SENT IN BY: Kathy Monahan, Breckenridge, MN

MATERIALS:

Clipboard, thin paper, textured objects such as leaves, paper clips, rubber bands, pieces of burlap or feathers, peeled crayons.

ACTIVITY:

Let one child at a time clip paper on the clipboard and put a textured object under the paper. Then have the child hold the paper down with one hand while rubbing the side of a crayon over the paper-covered object with the other hand. The child can then repeat the procedure, using a different object and crayon color.

HINT:

Use embossed greeting cards for seasonal crayon rubbings.

SENT IN BY: Sr. Mary Bezold, Melbourne, KY

SIMILAR IDEA SUBMITTED BY: B. Silkunas, Philadelphia, PA

CRAYONS

"texture rubbings"

"leaf rubbings"

Marking with . . .

MATERIALS:

Cardboard, construction paper, peeled crayons.

PREPARATION:

Cut the cardboard into small circle, square, triangle or free-form shapes. Make several shapes for each child.

ACTIVITY:

Have the children arrange their cardboard shapes on a table top any way they wish. Next, have them lay their papers over their shapes. Then, let them rub across their papers with the sides of their crayons to make impressions of their shapes. Encourage them to press down hard while coloring.

VARIATION:

Let the children arrange other flat objects under their papers such as corrugated cardboard, combs, graters, popsicle sticks or toothpicks. Some of the most fun items for preschoolers to use are coins.

SENT IN BY: JoAnn Wilson, Boise, ID

"shape rubbings"

CHALK

MATERIALS:

A box of colored chalk.

ACTIVITY:

Take the children outside and let them draw on the sidewalk or blacktop with chalk. The chalk will wash off in the rain. Let the children make their own designs. Or, draw outlines of their bodies as they lie on the ground and let them decorate their body shapes.

SENT IN BY: Cynthia Holt, Danbury, CT

VARIATION: From Cathryn Abraham, St. Charles, IL

Have the children dip their chalk in water before coloring with it. Discuss the change in color.

"sidewalk art"

MATERIALS:

Sandpaper of different textures, various colors of chalk, shallow containers, water.

PREPARATION:

Cut sandpaper into desired sizes and pour water into containers.

ACTIVITY:

Have the children dip colored chalk into water and then draw designs on the sandpaper. Encourage them to use several different colors.

SENT IN BY: Laura A. Leicht, Albany, NY

CHALK

"sandpaper art"

Marking with . . .

MATERIALS:

Construction paper, colored chalk, water, brushes, pie tins.

PREPARATION:

Fill pie tins with water.

ACTIVITY:

Have the children brush water all over their papers. Then let them use colored chalk to draw designs while their papers are still wet.

VARIATION:

Have the children draw on dry paper with wet chalk. Experiment with different effects by letting them dip chalk into water, buttermilk or diluted liquid starch before drawing their designs.

CHALK

"water pictures"

PENS

"spin art"

MATERIALS:
Record player, paper plates, felt markers, pencil.

PREPARATION:
Using a pencil point, punch holes in the centers of the paper plates.

ACTIVITY:
Let the children take turns doing this activity. Place a paper plate on the turntable of a record player and turn on the machine. Have the child hold a felt marker on the plate as it spins around. Encourage him or her to move the marker back and forth to create various patterns. Using a variety of colors will add to the children's designs.

SENT IN BY: Paula Omlin, Maple Valley, WA

VARIATION:
Paper circles or squares can also be used.

"handy holders"

HINT: From Cynthia Holt, Danbury, CT
To help children put tops back on felt markers so they don't dry out, try this idea. Mix plaster of Paris in a small bowl such as a Cool Whip container. Set marker tops in the wet plaster, hole ends up, making sure not to cover the holes. When the plaster dries, the children can easily stand the markers upright in the appropriate tops after they have finished using them.

Marking with . . .

MATERIALS:

Heavy-duty white paper towels or white cotton cloth, black marking pens, cardboard, sewing machine or needle and thread.

PREPARATION:

Make a simple mitten-shape pattern for a hand puppet. Then make a puppet for each child by placing the pattern on two heavy-duty paper towels or pieces of cloth and cutting around the pattern. Sew the edges of the puppet together, leaving the bottom open.

ACTIVITY:

Let the children draw spooky faces on their ghost puppets with black marking pens. To prevent the ink from soaking through to the backs of the puppets, slide pieces of cardboard inside before the children start drawing. The nice thing about this activity is that there are no right or wrong ghost faces. Any face a child draws will be correct.

"ghost puppets"

125

CINNAMON STICKS

"scented necklaces"

MATERIALS:
Sandpaper, cinnamon sticks, yarn, hole punch.

PREPARATION:
Cut sandpaper into pieces about 3 inches square. Cut yarn into desired lengths for necklaces.

ACTIVITY:
Let each child "color" on a piece of sandpaper with a cinnamon stick. Then help the child punch a hole near the top of the sandpaper square, thread a piece of yarn through it and tie the yarn around his or her neck. The child can then sniff the spicy sandpaper while wearing the necklace.

SENT IN BY: Nancy J. Heimark, Grand Forks, ND

MATERIALS:
Plastic dishpan, sand, water.

PREPARATION:
Fill dishpan with 3 inches of sand and add a little water.

ACTIVITY:
Show the children how to draw and erase in the sand. Then invite the children to use their fingers to draw their own designs or letters.

SENT IN BY: B. Silkunas, Philadelphia, PA

FINGERS IN SAND

"letters"

TEARING OR CUTTING

ASSORTED PAPERS

MATERIALS:

Magazines, catalogs, newspapers, construction paper, sandpaper, tissue paper, aluminum foil, waxed paper, paper towels, glue.

ACTIVITY:

Toddlers love to tear paper. Let them tear pages cut from magazines, catalogs and newspapers just for the fun of it. Or, let them tear colorful paper and glue the pieces on black construction paper. To add variety, let them tear interesting textured papers such as sandpaper, tissue paper, aluminum foil, waxed paper or paper towels.

"group collage"

VARIATION:

Have the children make a torn-paper collage. Attach a large sheet of paper to a wall and provide various kinds of paper for the children to tear. As they work, guide them by asking questions such as, "Can you tear a tiny piece of paper? Can you tear a huge piece of paper?" Then help them to glue their torn paper pieces on the large sheet of paper.

SENT IN BY: Melode Hurst, Grand Junction, CO

MATERIALS:

Wallpaper book or sheets of holiday giftwrap, construction paper, glue, scissors.

ASSORTED PAPERS

ACTIVITY:

Let the group choose a page from the wallpaper book or a sheet of giftwrap and cut it into pieces. Some pages or papers will have distinct patterns to follow. But for those just beginning to use scissors, cutting the pretty paper in any fashion will be an enjoyable experience.

"snip-snip-snip"

VARIATION:

For those children not ready to cut with scissors, tearing the paper and gluing it on construction paper is a good activity.

SENT IN BY: Diana Shindler, Bay City, TX

Tearing or Cutting . . .

MATERIALS:

9"x12" construction paper, various colors of construction paper scraps, scissors, paste.

"shape pictures"

ACTIVITY:

Let the children cut the construction paper scraps into any shapes they wish. Encourage them to cut some long, some short, some fat and some thin. Then have them paste their shapes on their sheets of construction paper to make unique and colorful collages.

HINT:

This is a terrific cutting and pasting activity for beginners. It gives them a lot of cutting practice without requiring them to follow lines or make particular shapes. They really enjoy this project!

SENT IN BY: Jane M. Spannbauer, So. St. Paul, MN

Tearing or Cutting . . .

PAPER

MATERIALS:
9"x12" blue construction paper, scraps of red and green paper, paste.

PREPARATION:
For each child, trace a large apple shape, including the stem, on a piece of blue construction paper.

"apples"

ACTIVITY:
Have each child tear red paper scraps into little pieces and paste them on his or her apple shape until the entire area is filled. Then have the child fill in the stem by pasting on pieces torn from green paper scraps.

"pumpkins"

VARIATION:
Follow the same procedure to make pictures of things such as pumpkins, flowers or snowmen.

"flowers"

HINTS:
This is an excellent activity for developing small hand muscles. The children become very involved and their finished pictures are always pretty, regardless of age.

"snowmen"

SENT IN BY: Jane M. Spannbauer, So. St. Paul, MN

Tearing or Cutting . . .

MATERIALS:

Yellow construction paper, scissors, marking pens.

PREPARATION:

Cut a circle out of yellow construction paper for each child.

ACTIVITY:

This is a good activity to use with beginning cutters. Have the children use scissors to snip around the edges of their paper circles to make "sun rays." When they have finished, have them bend their sun rays, some in and some out, for contrast. Then help the children to draw "happy faces" on their suns with marking pens.

PAPER

"suns"

PAPER

"snip-snip-snip"

MATERIALS:

Paper, scissors.

PREPARATION:

Cut paper into strips approximately 1 inch wide.

ACTIVITY:

This is an excellent activity to use for a child's first experience with scissors. First, show the child how to hold and manipulate the scissors. Then let him or her practice snipping the paper strips into little pieces. You can save the clippings and use them later to make scrap-paper collages.

131

Tearing or Cutting . . .

NEWSPAPER

"spooky shapes"

MATERIALS:
Newspaper (want ads or financial tables), black and orange crayons.

ACTIVITY:
Let the children tear newspaper into spooky-looking shapes. Then have them use black and orange crayons to make Halloween scribble pictures.

SENT IN BY: Janet Helgaas, Luverne, MN

MAGAZINES

"scrapbooks"

MATERIALS:
Brown paper lunch bags, hole punch and yarn or stapler, glue, scissors, crayons, old magazines or catalogs.

PREPARATION:
Staple or tie three bags together to make a book for each child. Write the child's name on the front.

ACTIVITY:
Let the children cut out pictures they like from magazines and paste them in their books. They may wish to color the fronts of their books or paste pictures there, too.

SENT IN BY: Annette Gagliardi, Minneapolis, MN

LACING

Lacing . . .

CARDBOARD SQUARES

"spider webs"

MATERIALS:
Cardboard, black yarn, tape.

PREPARATION:
Cut an 8-inch square piece of cardboard for each child. Cut slits ½ inch deep around the sides, about 1½ inches to 2 inches apart. Cut yarn into 6-foot lengths. Tape the end of a piece of yarn on the back of each card and pull it through one of the slits.

ACTIVITY:
Let the children cross the yarn back and forth over the fronts of their cardboard squares, attaching it through the slits. Slits can be used more than once. Have them continue until the yarn resembles a spider web.

SENT IN BY: Mary Whaley, Kentland, IN

Lacing . . .

GREETING CARDS

MATERIALS:

Old greeting cards, yarn, hole punch, tape.

PREPARATION:

Cut the fronts off greeting cards and punch holes around the edges about ½ inch to 1 inch apart. Cut yarn into appropriate lengths for lacing. Tape one end of a piece of yarn to the back of each card.

ACTIVITY:

Let the children lace yarn through the holes in their cards. When they have finished, trim the remaining yarn ends and tape them to the backs of the cards.

HINT:

Use appropriate cards for each holiday, such as Easter cards for Easter or Christmas cards for Christmas.

SENT IN BY: Sr. Mary Bezold, Melbourne, KY

HINT:

Lacing will be easier if you dip one end of each piece of yarn into wax or glue or wrap it with tape to make a "needle."

"holiday pictures"

RIGATONI

"Christmas wreaths"

"necklaces"

MATERIALS:

Rigatoni, food coloring, rubbing alcohol, curling ribbon or string, tape.

PREPARATION:

Dye rigatoni using food coloring and rubbing alcohol. Cut ribbon or string into desired lengths and wrap ends with tape.

ACTIVITY:

Let the children string rigatoni on their pieces of ribbon. Tie the ends of the ribbons together and curl them by pulling them over the blade of a pair of scissors.

SENT IN BY: Janet Harles, Moorhead, MN

BUTTONS

"necklaces"

MATERIALS:

Long shoelaces, buttons with large holes.

PREPARATION:

Knot one button at the end of each shoelace.

ACTIVITY:

Invite the children to string a selection of buttons on their shoelaces to make necklaces.

SENT IN BY: B. Silkunas, Philadelphia, PA

Lacing . . .

"easy weaving"

MATERIALS:

Cardboard, several different colors of yarn.

PREPARATION:

Cut cardboard into geometric shapes such as circles, triangles, squares and rectangles. Cut five or six slits around the edge of each shape. Cut yarn into pieces about 2½ feet long.

ACTIVITY:

Let the children decorate their cardboard shapes by winding yarn around and around them, each time passing the yarn through one of the slits. Encourage them to crisscross their shapes in any way they wish to make designs. When the children have finished decorating their shapes, have them bend the portions between the slits in and out to create a 3-D effect.

Lacing . . .

STRAWS

"heart necklaces"

MATERIALS:

Red construction paper, straws, yarn, tape, pencil or hole punch.

PREPARATION:

Cut approximately eight 3-inch hearts out of red construction paper for each child. In the center of the hearts, use a pencil point or hole punch to make holes that are slightly smaller than the holes in the straws you are using. Cut straws into 1½-inch sections. For each child, cut a piece of 18-inch yarn. Tie a straw section at one end and tape the other end to make a "needle."

ACTIVITY:

Let the children make necklaces by stringing the hearts between the straw sections on their pieces of yarn. Have them begin and end their necklaces with a section of straw. Tie the yarn ends together when the children have finished.

"leis"

VARIATION:

Cut flower shapes out of construction paper and let the children string them with straw sections to make colorful leis.

MISCELLANEOUS ART

SOAP ART

"snow trees"

"snow scenes"

"snow bunnies"

MATERIALS:

Evergreen twigs, Ivory Snow powder, water, small bowl, eggbeater or mixer, flowerpots or boxes, sand or dirt.

PREPARATION:

Mix soap powder with a small amount of water in small bowl. Beat until stiff with an eggbeater or mixer. Put sand or dirt in the flowerpots or boxes.

ACTIVITY:

Have the children spread the soap mixture on the evergreen twigs to create "snow-covered trees." Then stand the twigs in flowerpots or boxes filled with sand or dirt.

VARIATION:

Have the children dab small bits of the soap mixture on black or dark blue construction paper to give the effect of snowflakes.

VARIATION:

Have the children spread the soap mixture on tagboard bunny shapes. When the soap dries, let them glue cotton ball "tails" on their bunnies.

SENT IN BY: Betty Ruth Baker, Waco, TX

VARIATION: From Laura A. Leicht, Albany, NY
The Ivory Snow mixture can be used for fingerpainting. Add food coloring to the water first, if desired. The soap will harden as it dries.

"fingerpainting"

VARIATION: From B. Silkunas, Philadelphia, PA

Mix a good quantity of Ivory Snow powder and water in a bucket. Then invite your children to work the mixture into "snowballs."

"snowballs"

VARIATION:

The Ivory Snow mixture can be molded into different shapes such as hearts, eggs, butterflies, etc. Allow two or three days for the soap shapes to dry. These make great Mother's Day gifts.

"holiday gifts"

Miscellaneous . . .

MATERIALS:

A baby food jar for each child, salt, colored chalk, scratch paper, ribbon, glue.

PREPARATION:

Place one or two spoonfuls of salt on a piece of scratch paper for each child.

"paperweights"

ACTIVITY:

Give each child a piece of colored chalk and have him or her rub the chalk into the salt. When the salt is colored, pour it into the child's jar. Then have the child repeat the process with more salt and a different color of chalk. Continue layering the colored salt in the jar until it is full. Later, the lids of the jars can be glued shut and ribbons can be tied around the tops to make paperweights.

HINT:

Clear plastic pill bottles may be substituted for the glass baby food jars, if desired.

SENT IN BY: Diane Torgan, Englewood, CO

Miscellaneous . . .

SHRINK ART

MATERIALS:

Commercial shrink-art plastic or plastic liver lids, permanent marking pens, hole punch, yarn, cookie sheet, aluminum foil, oven.

"holiday ornaments"

PREPARATION:

Cut plastic into 6-inch shapes such as circles, diamonds or triangles. Punch two holes touching one another to make one large hole at the top of each shape. Preheat oven to 275 degrees.

ACTIVITY:

"heart necklaces"

Have the children use several different colors of permanent marking pens to color or scribble all over their plastic shapes. When the shapes shrink, even scribbles will make lovely designs. Arrange the plastic shapes on a foil-covered cookie sheet, place in the oven and watch the plastic shrink and curl. (If plastic curls too much, use a cooler oven.) When the plastic shapes become thick and lay flat, remove them from the oven immediately and press with a smooth object. Let the shapes cool and insert yarn in the holes for hanging.

HINT:

Outline each shape with a permanent marking pen for a more finished effect.

SENT IN BY: Kathy Sizer, Tustin, CA

★ **WARNING:**

The heating of plastics can give off a gas which could affect people with respiratory disorders or allergies. Make sure your work area is well-ventilated and that children stand far back from the heat source. Children with severe respiratory disorders should avoid the area entirely.

Miscellaneous . . .

MATERIALS:

Construction paper, colored tissue paper or crepe paper streamers, spray bottles, water.

PREPARATION:

Cut tissue or crepe paper into desired shapes and sizes. Fill spray bottles with water.

ACTIVITY:

Have the children place colored tissue or crepe paper on construction paper and spray with water. Then have them remove the colored paper to see how it "bled" onto the construction paper, creating designs.

SENT IN BY: Cathryn Abraham, St. Charles, IL

"mosaic eggs"

VARIATION:

This method makes great mosaic Easter eggs. Have the children brush water all over white paper egg shapes and cover shapes with squares of colored tissue paper. Then have them paint over the tissue squares with more water. Let the children remove the tissue squares when their papers have dried.

COLOR ART

"changing colors"

MATERIALS:

Red, yellow and blue crepe paper, tweezers, small jars, popsicle sticks, two buckets.

PREPARATION:

Cut the crepe paper into 1-inch squares. Fill the small jars and one of the buckets with water.

ACTIVITY:

Let the children pick up the paper squares with tweezers, drop them in jars of water and stir with popsicle sticks. Have them add other colors and watch how new colors are created. When the water in their jars becomes muddy, have them pour it into the empty bucket and add clean water from the other bucket so they can continue experimenting with other color combinations.

SENT IN BY: Ellen Javernick, Loveland, CO

HOLE-Y ART

"peekaboo colors"

MATERIALS:

Backing material such as heavy cardboard, wood, styrofoam or cork-board, pencils or nails, various colors of construction paper, black construction paper, tape.

PREPARATION:

Cut colored construction paper into 5-inch squares and tape them on backing material.

ACTIVITY:

Have the children use pencils or nails to punch holes in their colored paper squares. Then let them place their squares on sheets of black construction paper and watch the holes "pop" out.

VARIATION:

For each child, choose several sheets of different colored paper and punch holes in them with a hole punch. Then staple the papers together to make a book with a different color peeking through the holes on each page.

SENT IN BY: Melode Hurst, Grand Junction, CO

"Christmas lights"

VARIATION:

Let the children punch holes in green Christmas tree shapes and paste them on colored paper or foil. The colors showing through the holes will look like Christmas tree balls or lights.

Miscellaneous . . .

SPAGHETTI ART

MATERIALS:
Cooked spaghetti, food coloring, construction paper.

PREPARATION:
Cook spaghetti according to package directions. Drain and add food coloring. Keep covered until ready to use.

ACTIVITY:
Let the children stick the wet spaghetti on their papers in any designs they wish. They really enjoy the color and feel of the warm noodles.

"sticky designs"

SENT IN BY: Evelyn Romzek, Ubly, MI

HINT:
If you want your children to keep their creations, use heavy background material. Construction paper will curl up as the spaghetti dries.

WIND ART

"paint designs"

MATERIALS:
White construction paper, paint, spoon.

ACTIVITY:
Go outside on a windy day. Give each child a piece of paper and drop on a few spoonfuls of paint. Then have the children hold up their papers and let the wind blow the paint into designs.

HINT:
If you don't want to wait for a windy day, you can get the same effect by having the children wave their papers back and forth in the air.

SENT IN BY: Heather Hogg, Sussex, New Brunswick

Miscellaneous . . .

IRON ART

"hearts"

"snowflakes"

"flowers"

MATERIALS:
Waxed paper, old crayon chunks, construction paper scraps, aluminum foil, cheese grater, thick dishtowel, iron.

PREPARATION:
Cut waxed paper into 9"x12" sheets. Plug in iron.

ACTIVITY:
Let each child grate crayon shavings onto a sheet of waxed paper. Then have the child place little pieces of torn colored paper and small chunks of aluminum foil on top of the shavings. Cover with another sheet of waxed paper and place a dishtowel over it. Then, using extreme caution, let the child help press the iron over the towel to make the crayons and the waxed paper sheets melt together. Later, you can cut the children's transparent creations into shapes such as hearts, snowflakes or flowers and use them as window directions.

SENT IN BY: Jane M. Spannbauer, So. St. Paul, MN

★ **WARNING:**
Activities that involve using an electric iron require adult supervision at all times.

Miscellaneous . . .

MATERIALS:

Construction paper, waxed paper, old crayons, plastic bag, hammer, iron.

PREPARATION:

Cut construction paper into leaf frames. Place crayons in a plastic bag and, depending upon ability, let the children help pound them into little pieces with a hammer. Cut waxed paper into sheets. Plug in iron.

"autumn leaves"

ACTIVITY:

Let the children place crayon pieces between two sheets of waxed paper. Then press over the papers with an iron to melt the crayons and waxed paper sheets together. Put leaf frames around the finished pictures and hang them in a window.

SENT IN BY: Mary Haynes, Lansing, MI

VARIATION: From Diane Dobson, Port Alberni, British Columbia

For each child, cut a butterfly shape from a double thickness of waxed paper. Let the child grate crayon shavings on one of the butterfly shapes and sprinkle on some glitter. Cover with the second butterfly. shape and place the two shapes on newspaper. Then, with the iron set on low, let the child help press the butterfly to melt the shavings and seal the waxed paper shapes together. Hang the finished butterflies in a window to bring Spring into the room!

"butterflies"

NAIL ART

MATERIALS:

Pieces of softwood, hammers, nails with large heads, woodworking table.

PREPARATION:

Check with a lumberyard for pieces of scrap softwood. Set up work table outside or in an area separate from other children.

"pounding fun"

ACTIVITY:

Let two or three children at a time hammer nails into pieces of softwood. Make sure an adult is always present to supervise. Very young children love working with these "grown-up" materials, and just pounding the nails is enough. The adult may need to hammer in the nails first to make them stable.

SENT IN BY: Cynthia Holt, Danbury, CT

"weaving fun"

VARIATION:

Let the children pound nails into pieces of softwood. Then have them weave colored rubber bands or pieces of yarn through the nails to create designs.

Miscellaneous . . .

IMPRESSION ART

MATERIALS:

Cornstarch, baking soda, water, saucepan, waxed paper, nature objects such as leaves, twigs and flowers.

PREPARATION:

In a saucepan, mix together 1 cup cornstarch, 2 cups baking soda and 1¼ cups water. Cook over medium heat until the mixture thickens. Cool, then flatten mixture between sheets of waxed paper.

ACTIVITY:

Let the children lay leaves, twigs, flowers or other nature objects on top of the cornstarch mixture and press them down firmly. Then have them remove the objects to see the detailed impressions they made.

"cornstarch pictures"

IMPRESSION ART

MATERIALS:

Plaster of Paris, tin pans, oil, paint, brushes, nature objects such as acorns, flowers or leaves.

PREPARATION:

Let the children help mix the plaster and water until it is the consistency of paste. Then grease the pans, pour in the plaster and let it harden slightly.

"plaster pictures"

ACTIVITY:

Have the children place their nature objects in the plaster and push them down very gently to make imprints. When dry, take the plaster shapes out of the pans, remove the nature objects and let the children paint the plaster shapes.

SENT IN BY: Mary Haynes, Lansing, MI

FOIL ART

"moonscapes"

MATERIALS:
A piece of cardboard for each child, aluminum foil, glue, small objects such as dried beans and seeds, popsicle sticks, styrofoam bits, etc.

PREPARATION:
Cut aluminum foil into pieces large enough to wrap around the sheets of cardboard.

ACTIVITY:
Have the children glue an assortment of small objects on their cardboard backgrounds. When the glue has dried, let them lay sheets of aluminum foil on top of their cardboard pieces and carefully press the foil around the glued-on objects. Then help them to fold the edges of the foil around the backs of their cardboard sheets.

CLOTHESPIN ART

"butterflies"

MATERIALS:
Colored tissue paper, spring-type clothespins, pipe cleaners, felt markers.

PREPARATION:
Cut tissue paper into 5-inch squares.

ACTIVITY:
Let each child make a butterfly by pinching opposite edges of a tissue paper square together in the middle and inserting the paper in the clasp of a clothespin. A pipe cleaner can then be wrapped around the top of the clothespin for antennas, and a face can be drawn on it with a felt marker.

SENT IN BY: Cathy Phillips, Clarkston, MI

Miscellaneous . . .

STRING ART

MATERIALS:

String or yarn, diluted white glue or liquid starch, dishes, waxed paper

ACTIVITY:

Let the children dip pieces of string into dishes of glue or starch. Then have them lay their strings on waxed paper to create designs. When the strings dry, they will become stiff and hold their shapes.

VARIATION:

Have the children wrap glue-covered string around small blown-up balloons. To cover each balloon, you will need about ten 12-inch pieces of string. When the strings have dried, pop the balloons. The children will then have large ball shapes to hang in the room or perhaps on a Christmas tree.

"holiday decorations"

FLOATING ART

"chalk prints"

"ink designs"

MATERIALS:

Construction paper, plastic dishpan, water, colored chalk, kitchen grater.

PREPARATION:

Cut construction paper into desired seasonal or holiday shapes. Fill the plastic dishpan with water. Let the children help grate various colors of chalk into powder.

ACTIVITY:

Let each child choose two or three colors of chalk and sprinkle the powder on top of the water. Then have him or her lay a shape on top of the water to absorb the chalk designs. Hang the shapes on a line or lay them out on a flat surface to dry.

VARIATION:

Instead of using chalk, place drops of India ink on top of the water, swirl to make a design and then lay paper on the water's surface.

SEASONAL INDEX

FALL ART

WINTER ART

SPRING ART

SUMMER ART

Totline® Publications

Teacher Books

BEST OF TOTLINE® SERIES
Totline Magazine's best ideas.
Best of Totline
Best of Totline Parent Flyers

BUSY BEES SERIES
Seasonal ideas for twos and threes.
Busy Bees—Fall
Busy Bees—Winter
Busy Bees—Spring
Busy Bees—Summer

CELEBRATIONS SERIES
Early learning through celebrations.
Small World Celebrations
Special Day Celebrations
Great Big Holiday Celebrations
Celebrating Likes and Differences

EXPLORING SERIES
Versatile, hands-on learning.
Exploring Sand
Exploring Water
Exploring Wood

FOUR SEASONS
Active learning through the year.
Four Seasons—Art
Four Seasons—Math
Four Seasons—Movement
Four Seasons—Science

GREAT BIG THEMES SERIES
Giant units designed around a theme.
Space • Zoo • Circus

LEARNING & CARING ABOUT
Teach children about their world.
Our World
Our Town

MIX & MATCH PATTERNS
Simple patterns to save time!
Animal Patterns
Everyday Patterns
Holiday Patterns
Nature Patterns

1•2•3 SERIES
Open-ended learning.
1•2•3 Art
1•2•3 Games
1•2•3 Colors

1•2•3 Puppets
1•2•3 Reading & Writing
1•2•3 Rhymes, Stories & Songs
1•2•3 Math
1•2•3 Science
1•2•3 Shapes

101 TIPS FOR DIRECTORS
Valuable tips for busy directors.
Staff and Parent Self-Esteem
Parent Communication
Health and Safety
Marketing Your Center
Resources for You
 and Your Center
Child Development Training

101 TIPS FOR PRESCHOOL TEACHERS
Creating Theme
 Environments
Encouraging Creativity
Developing Motor Skills
Developing Language Skills
Teaching Basic Concepts
Spicing Up Learning Centers

101 TIPS FOR TODDLER TEACHERS
Classroom Management
Discovery Play
Dramatic Play
Large Motor Play
Small Motor Play
Word Play

1001 SERIES
Super reference books.
1001 Teaching Props
1001 Teaching Tips
1001 Rhymes & Fingerplays

PIGGYBACK® SONGS
New songs sung to the tunes of childhood favorites!
Piggyback Songs
More Piggyback Songs
Piggyback Songs for Infants
 and Toddlers
Holiday Piggyback Songs
Animal Piggyback Songs
Piggyback Songs for School
Piggyback Songs to Sign
Spanish Piggyback Songs
More Piggyback Songs for School

PROBLEM SOLVING SAFARI
Teaching problem solving skills.
Problem Solving—Art
Problem Solving—Blocks
Problem Solving—Dramatic Play
Problem Solving—Manipulatives
Problem Solving—Outdoors
Problem Solving—Science

SNACKS SERIES
Nutrition combines with learning.
Super Snacks
Healthy Snacks
Teaching Snacks
Multicultural Snacks

THEME-A-SAURUS® SERIES
Classroom-tested, instant themes.
Theme-A-Saurus
Theme-A-Saurus II
Toddler Theme-A-Saurus
Alphabet Theme-A-Saurus
Nursery Rhyme Theme-A-Saurus
Storytime Theme-A-Saurus
Multisensory Theme-A-Saurus

Puzzles & Posters

PUZZLES
Kids Celebrate the Alphabet
Kids Celebrate Numbers
African Adventure
 2-Sided Circle Puzzle
Underwater Adventure
 2-Sided Circle Puzzle
Bear Hugs 4-in-1 Puzzle Set
Busy Bees 4-in-1 Puzzle Set

POSTERS
We Work and Play Together
Bear Hugs Health Posters
Busy Bees Area Posters
Reminder Posters

Story Time
Delightful stories with related activity ideas, snacks, and songs.

KIDS CELEBRATE SERIES
Kids Celebrate the Alphabet
Kids Celebrate Numbers

Parent Books

A YEAR OF FUN SERIES
Age-specific books for parenting.
Just for Babies
Just for Ones
Just for Twos
Just for Threes
Just for Fours
Just for Fives

BEGINNING FUN WITH ART
Introduce your child to art fun.
Craft Sticks • Crayons • Felt
Glue • Paint • Paper Shapes
Modeling Dough • Tissue Paper
Scissors • Rubber Stamps
Stickers • Yarn

BEGINNING FUN WITH SCIENCE
Spark your child's interest in science.
Bugs & Butterflies • Plants &
Flowers • Magnets • Rainbows
& Colors • Sand & Shells
• Water & Bubbles

LEARNING EVERYWHERE
Discover teaching opportunities everywhere you go.
Teaching House
Teaching Trips
Teaching Town

SEEDS FOR SUCCESS
Ideas to help children develop essential life skills for future success.
Growing Creative Kids
Growing Happy Kids
Growing Responsible Kids
Growing Thinking Kids

LEARN WITH PIGGYBACK SONGS BOOKS AND TAPES
Captivating music with age-appropriate themes get children moving.
Songs & Games for Babies
Songs & Games for Toddlers
Songs & Games for Threes
Songs & Games for Fours

Totline® books and resources are available at parent and teacher stores. For the dealer nearest you or a catalog, call 1-800-421-5565